THE JOY OF

40 HAPPY LESSONS FOR PAINTING
THE WORLD AROUND YOU

EMMA BLOCK

Running Press

PHILADELPHIA

For my Grandpa Lawrence,
who introduced me to art from an early
age and who has always painted
just for the joy of it

Running Press
Hachette Book Group
1290 Avenue of the Americas, New York, NY 10104
www.runningpress.com
@Running_Press

Printed in China

First Edition: August 2018

Published by Running Press, an imprint of Perseus Books, LLC, a subsidiary of Hachette Book Group, Inc. The Running Press name and logo is a trademark of the Hachette Book Group.

The Hachette Speakers Bureau provides a wide range of authors for speaking events. To find out more, go to www.hachettespeakersbureau.com or call (866) 376-6591.

The publisher is not responsible for websites (or their content) that are not owned by the publisher.

Print book cover and interior design by Amanda Richmond.

Library of Congress Control Number: 2018935662

ISBNs: 978-0-7624-6329-9 (hardcover), 978-0-7624-9160-5 (ebook), 978-0-7624-6585-9 (ebook), 978-0-7624-6586-6 (ebook)

RRD-S

10 9 8 7 6 5 4 3

CONTENTS

INTRODUCTION

Brief History

Watercolor is one of the oldest forms of painting known to man. Cavemen ground pigments from the earth and combined them with water to decorate the walls of their caves, and watercolor was used as far back as ancient Egypt and the European Middle Ages to embellish elaborate manuscripts. Watercolors today pay homage to their ancient roots with colors like yellow ocher, burnt umber, and raw sienna, still made from natural pigments derived from the earth.

The medium of watercolor really came into its own during the Renaissance, utilized by artists like Albrecht Dürer. Dürer was one of the first artists to fully realize the true subtlety and capabilities of watercolor. One of the greatest masters of watercolor was J.M.W. Turner, whose skillful handling of the medium creates powerful, evocative scenes with a great economy of brushstrokes. When the Tower of London caught fire in 1841, Turner grabbed his watercolors so that he could capture the scene unfolding with the greatest possible efficiency.

Watercolors have always been the younger sibling to oil paints, less respected and less likely to be considered great art. Watercolors were often used to create rough sketches, before a final piece was created in oils. In the eighteenth century, artists began to use watercolors to explore the natural world, which is possibly the reason that watercolors are still associated with landscape painting today. But there is so much more you can paint with watercolors than just fields and streams.

Why I Love to Paint

(AUTHOR'S NOTE)

I GOT MY FIRST SET OF WATERCOLORS WHEN I WAS SEVEN, WHICH I WON IN A competition run by the post office. My first watercolors (which I still have) were a cheap set, designed for children, but what they lacked in quality they made up for in exciting vibrant tones. The way they came alive when mixed with water was a kind of magic.

At some point I stopped using watercolors as I explored new materials at university. Watercolors felt too old-fashioned and safe, and I wanted my work to have more of an edge. I started experimenting with collage, creating incredibly detailed cut-paper illustrations. They were so intricately created that people mistook them for digital artwork. I cut out tiny pieces of paper, then painted them to add shadows, texture, and detail before gluing them together. When my final project at university was graded by an external moderator, she commented that it must be time consuming to paint onto tiny bits of paper, and why didn't I lose the bits of paper and just do a painting? And so painting snuck back in, and cut paper gradually faded out of my work. By bringing in layers of detail and texture, I found a new way to use watercolors that felt fresh and modern and me.

Modern Watercolors

Watercolor has a charm all its own. What initially seems like a simple medium to master actually has many subtleties that will reveal themselves to you the more you continue to work with it. The main thing that characterizes watercolor is its immediacy, the magic of moving pools of pigment suspended in water across the paper, working quickly in the moments before it dries and sets. The ability to make quick decisions whilst working is vital. Watercolors often have a freshness and apparent effortlessness to them, though as the artist you might feel that painting one feels anything *but* effortless.

Watercolor is having something of a renaissance, and it is a popular medium for artists and illustrators working today. There is also a growing trend for its use in homeware, stationery, and decor. In an increasingly digital world, there is something so appealing about the way a layer of paint spreads over a page in an organic and unpredictable way. It's

something that cannot be recreated digitally. Many artists are taking this incredibly ancient painting method and turning it into something new and fresh, with innovative use of materials and processes. If you thought of watercolor as old-fashioned or musty, a quick browse through Instagram or Pinterest will change your mind.

Mindfulness and Watercolor

I believe that everybody is creative and that everybody's life would benefit from having a little bit more creativity in it. When children paint or draw, they create so freely, confidently, and enthusiastically. Unfortunately, many people's explorations into drawing and painting stop when they leave school, and in this increasingly digital age I think there is a desire to return to the handmade. There is something so satisfying about creating something by hand, no matter how simple it is. Painting

with watercolor is a mindful activity by its very nature, as it forces you to be present. Painting occupies your mind in a way that is relaxing and allows you to put your thoughts and worries on hold for the moment. Painting is explorative, experimental, and immediate. Mistakes will be made, and there is no undo button to press. We can either incorporate our mistakes into the piece or we can start again from scratch, but either way we can only move forward, not backward.

Watercolor doesn't lend itself to going back to a half-finished painting; it works best when a painting is created in one sitting. Leaving a wash half-finished and going to make a cup of tea would be a mistake. Whilst a wash is still wet you can continue to manipulate it on the page, but as soon as it starts to dry, what's done is done. It can be a race against time to paint a large consistent wash whilst parts start to dry before you are finished. In these moments, controlling the color on the paper is your only concern. To paint with watercolor you must be in the moment.

Before You Begin

When it comes to watercolor, the clue is in the name. The thing that makes watercolor so unique is the combination of transparent color and water. Water is what allows the color to flow freely across the paper, pooling, settling, running, and blending into other colors. The true joy of watercolor is mastering the many effects that can be created with a combination of pigment and water on paper, but also surrendering to the spontaneous nature of it. In this book we will cover a variety of watercolor techniques, as well as the basic materials needed, color theory, color mixing, and step-by-step watercolor projects.

When I was researching this book, I found a lot of watercolor books that were prescriptive craft-type books, and I was surprised by their use of negative language. Words like "ugly," "destroy," and "disaster" were used in the first few

pages. To me there are no ugly mistakes; there are paint effects that you were expecting and those that you weren't. Learning to use watercolors is about creativity and experimentation, and to me that is always beautiful. My approach to watercolor painting is to break all the rules and work in a way that makes you happy. Whilst I cannot promise that painting with watercolors will always be easy, it is an engaging, inspiring, and rewarding pursuit. I hope you find great joy in using this book and learning the art of modern watercolors.

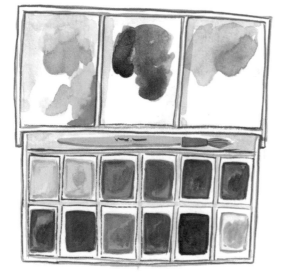

Materials

The first thing you need to do is gather your materials. The basic supplies needed are paint, brushes, paper, sketchbooks, pencils, and a few other miscellaneous items like colored pencils and masking fluid.

PAINT

Watercolor comes most commonly in pans and tubes, but it can also be found in concentrated liquid form and sticks.

Which you use is just personal preference. I use both pans and tubes for different reasons. Watercolor pans are convenient and portable. The box that holds the pans of paint usually has a palette built in, which is perfect for painting on location. Pans of paint are very low-maintenance, and an old set can still be used years later. You can buy a set of watercolors that contains a number of pans in a box, and this is the best way to get started. You can also buy individual pans, which is great if you're running out

of your favorite color or want to try a new color.

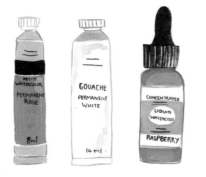

Tubes are fiddly to use, as you need to have a palette to squeeze the paint onto and then remember to put all the little lids back on afterwards. If you forget to do this, they will start to dry out. However, tubes of watercolor are convenient for mixing up a large amount of a particular color, as you can squeeze out as much as you need and then add the water. You can also use the paint without water, which can create some interesting dry-brush textures. When using tubes, always squeeze the paint onto a palette. Don't use a brush to scoop the color out: this can damage the brush and contaminate the color inside the tube. Tubes can be bought in sets or individually, and there is a huge range of colors available.

Concentrated liquid watercolors are all dye-based, which means they give beautiful vivid results that are not as lightfast as traditional pigment-based paints. The term *lightfast* refers to how quickly the colors fade in natural light; dye-based inks are designed for work that is going to be reproduced, like illustrations. Because they are not pigment-based, they don't have the same names as traditional watercolors and are instead named after fruit, flowers, and things that they resemble, rather than traditional pigments. These concentrated liquid watercolors are lovely to use but very expensive, and I would recommend using a more traditional set of watercolors to start with.

When you start shopping for watercolors, you will notice a huge variation

in price. Avoid cheap children's paint and go for a good-quality professional brand. Brands to look out for include Winsor & Newton, Schmincke, Sennelier, and Daniel Smith. Watercolors usually come in both student and professional quality. When first learning, I would definitely recommend starting with a student set. A set of professional/artist-quality paints can easily be five times the cost of a student set. A good-quality student set will be perfectly adequate for learning to paint. So what's the difference between student and professional quality? Professional-quality paints are more highly pigmented. This means that you will pick up much more color from swiping your wet brush across the pan once, compared with a student set. With the student-range paints, there is more binder and less pigment, so you may have to work your brush across the dry paint several times before picking up a sufficient amount of pigment. Colors from an artist's set should dilute very well

and retain a pure brightness even when mixed with lots of water. They should also be very transparent. One advantage to artist-quality paint is that they are more lightfast, which means your artwork would last longer without fading, which is obviously a concern if you plan to sell your work in a gallery or display it in your home. However, the difference between a picture painted with artist-quality paints and with student-quality paints isn't usually very noticeable to the untrained eye.

There is a huge range of colors available. The set that I use most often has fourteen colors in it. I wouldn't recommend buying a set with any more than twenty colors when you start out, and only twenty colors are used in this book. The danger with having every possible color available in your palette is that you will never learn to mix your own shades because you're always able to use them straight out of the box. Once you are experienced in mixing

Cool Primary Colors

| Lemon Yellow | Prussian Blue | Permanent Carmine |

Warm Primary Colors

| Cadmium Yellow | Ultramarine Blue | Cadmium Red Pale |

Earth Colors

Yellow Ocher Burnt Umber Burnt Sienna

colors, you will be able to mix almost any shade you need. Often when people first start painting with watercolor they only use the colors straight out of the box, but by mixing your own colors you're creating something more sophisticated and nuanced.

Most sets of watercolors will have roughly the same range of colors, which is designed to allow the greatest variety of mixing possibilities. Often they will contain pans of six primary colors: a

warm set and a cool set. You'll have two reds, two blues, and two yellows. They will also contain the three earth colors, usually yellow ocher, burnt sienna, and burnt umber, as well as a warm and a cool green and black and white. The inclusion of black and white is somewhat controversial among traditionalists, but I find them invaluable. Larger sets of paint will contain every color in the rainbow, but I find the colors mentioned above a good place to start. You can buy sets that include metallic and pearlized watercolor paints. I'm not usually a traditionalist, but I don't really class these as true watercolor paints because they are not transparent; however, they can be fun to use.

Sets of watercolors often contain a pan of white paint. This is usually Chinese white, which is a semi-opaque white used for mixing. Chinese white can be used to lighten a color instead of adding water. The more diluted a color is, the more difficult it is to control on the paper. By using Chinese white you can create very pale colors that are easier to work with and even in tone. Chinese white is great for creating soft pastel tones, and I often use white when I mix skin tones.

I always like to have a tube of permanent white gouache in my kit, which is an opaque white. White gouache is very useful for adding white details on top of a dark painted background. Gouache is essentially a completely opaque watercolor. It has the same

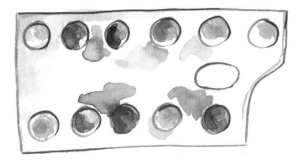

pigments as watercolor and is re-wettable once dried on the palette. It has a very flat, matte appearance, which is why it was traditionally favored by designers and illustrators. Gouache behaves very differently from watercolors, and it really deserves a whole book of its own. So to keep things simple I will only be using watercolors in this book, but a tube of white gouache is a useful addition to any watercolorist's kit.

You can mix your colors in the lid of your paint box, or you can use a separate palette. You can buy plastic, ceramic, and metal palettes for mixing paint. Ceramic is the best surface for mixing watercolors. When using a plastic palette, the surface can be too shiny and the diluted paint can form little droplets, which are difficult to pick up with your brush, whereas the ceramic surface allows the paint to stay in one pool of liquid, making it easy to mix and pick up with your brush. An enameled metal palette is also an ideal surface for watercolors, with the benefit of being lightweight and robust, though they are less commonly stocked in art-supply shops. A white ceramic palette with wells for mixing is ideal, but a white saucer or small plate works very well too.

BRUSHES

There are three parts to a paint brush: (1) the handle, usually made of wood but sometimes plastic, (2) the bristles, either animal hair or synthetic, and (3) the ferule, or metal part that holds the bristles in place. Watercolor brushes come in a huge variety of sizes, shapes, and quality. The best watercolor brushes are made from sable, which is animal hair. Sable brushes hold and distribute paint excellently, and even a large brush will form a very fine point. However, sable brushes are expensive and,

because they are made from animal hair, some people prefer not to use them for ethical reasons. For a beginner, I think a selection of good-quality synthetic brushes is ideal. I would suggest getting a selection of round brushes in a variety of sizes from small to large. I tend to work on quite a small scale, so my most-used brush sizes are on the small side. Smaller brushes wear out more quickly because they have fewer bristles. You know your brush needs replacing when it no longer keeps a point, and stray hairs stick out. For most general watercolor painting, you would want to use a round brush. Large flat brushes, Filbert brushes, or mop brushes can be useful for painting large washes of color. A rigger is good for fine lines and was traditionally used to paint the intricate

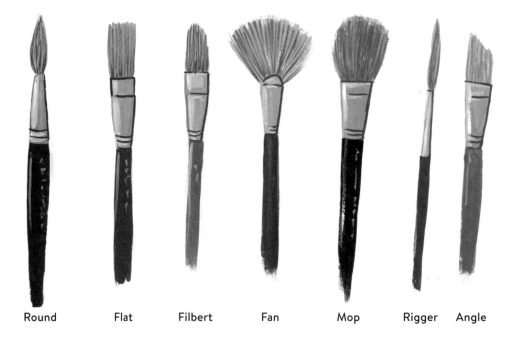

Round Flat Filbert Fan Mop Rigger Angle

rigging on a ship, hence the name. An angled brush can help you create fine points. When you are more confident in painting and have identified which brush sizes are most useful to you, it is then worth investing in a few sable brushes.

After finishing painting, make sure you rinse your brush thoroughly with clean water until all the pigment is removed from the bristles and the water runs clear. Never leave a brush point-down in a pot of water to soak, as this will damage the bristles. Also, the wood of the handle can absorb water and cause the painted surface of the handle to crack and the ferule to become loose.

I hold my brush in what is called the classic tripod grip, which means the brush is held lightly between my thumb and my first two fingers. This hold means I can vary the angle of the brush easily. When you're painting, try not to hold the brush in a tight fist, but hold it lightly with your fingers at the point where the ferule meets the handle. If you hold the brush too close to the bristles you won't have much range of movement, and if you hold too far up the handle you won't have much control.

A new type of brush that I enjoy using is what's known as a waterbrush. These are a Japanese invention, and water is held in the plastic barrel of the handle. This means that when you are painting you don't need to have a pot of water, which makes them ideal for painting on location. Instead of washing the brushes in between colors, you just need to dab the brush on a tissue until the pigment is removed from the bristles.

PAPER

There are three distinct types of watercolor paper, but within those three types there are many subtle differences between brands. It's really a case of trying a few and seeing what you like. The most commonly used watercolor paper is cold pressed, also sometimes called "not," since it is not hot pressed

(it doesn't make a lot of sense). This is the most versatile watercolor paper, as it has a subtle texture that helps the paint flow and spread evenly. This paper suits most paintings.

Hot-pressed paper has a very smooth finish, and it is ideal for fine, detailed work; however, some people find this paper difficult to use because the paint tends to slide over the paper rather than remaining trapped in the paper's texture.

Rough paper has the roughest texture, as the name suggests, and is mostly used for landscapes or abstract paintings. I don't use this paper, as it isn't suited to my style of painting.

Paper can be bought in individual sheets, sketchbooks, and pads. Paper comes in a variety of sizes, from postcard size up to huge sheets of paper. You can also buy watercolor paper in a variety of shapes, from square to long, thin rectangles. Paper that is 6 x 8 inches or 8 x 10 inches is an ideal size and shape to work on. The most expensive

paper is made of 100 percent cotton rag, rather than wood pulp. Cotton rag paper is beautiful to use and very durable; however, it is very expensive, so I would suggest starting with a good-quality wood-pulp paper. Brands to look out for include Bockingford, Canson, Arches, and Fabriano. Each brand has its own personality and subtle differences in color and texture. It's important when you're starting out to find a watercolor paper that you like. I prefer a natural organic texture to a more repetitive, organized texture. Paper also comes in a variety of weights. I would recommend using paper at least 140 pounds (per 500 sheets).

Traditionally, watercolor paper is always stretched before you start painting. If you are using a lightweight watercolor paper (under 140 pounds), or you are working on a piece larger than 8 x 10 inches, you may need to stretch your paper. This is because when a wash of watercolor is applied to a thin

piece of paper, the paper will buckle and wrinkle. I always use watercolor paper straight from the pad, as my style doesn't use a lot of water, so I don't find that the paper buckles. Whether you need to stretch the paper will depend on your style of painting and the size that you are working at. A good-quality heavy paper shouldn't need stretching for small illustrations like the ones in this book.

To stretch your paper, you will need a wooden board that is bigger than your piece of paper, gummed tape, and a sponge. Lay your paper onto the board and cut four lengths of tape. Gently dampen the paper using a wet sponge and wet the back of the tape. Whilst the paper is still wet, lay the tape down on each edge so it is secured to the wooden board. Allow the paper to dry naturally. As it dries the paper will become flat and will be held tightly in place by the tape. You would then do your painting whilst the paper is still attached to the board, and only cut away the tape once the painting is completely finished. Obviously, this process requires some preplanning, and takes away some of the spontaneous element of watercolor, which is why I personally don't use it, but it is useful when creating a large piece. Many brands of watercolor paper sell pads that are gummed on two or more sides, which keeps the paper flat whilst you are working on it and means you don't need to stretch it.

One of the most important things to consider when choosing a paper to work on is its shade of white. The whiteness of the paper shows through the transparent washes of color and brings the painting to life. You can use watercolors on tinted paper, such as cream or pale gray, but this color will show through the transparent watercolor. As an illustrator who scans and digitally reproduces her work, a nice white background is easier to work with.

SKETCHBOOKS

You can buy sketchbooks designed especially for watercolors with thicker-than-usual pages. The issue with painting in a sketchbook is waiting for each page to dry before going on to the next one, and getting the book to lie flat. I don't personally create final pieces in a sketchbook, but I like to take a sketchbook with me when traveling to sketch and paint on location. A small hardback sketchbook is ideal for this. Global Art Materials, Inc., has a range of watercolor sketchbooks called the Travelogue Series. They also sell a range of sketchbooks called Flexi-Sketch, which is my favorite sketchbook for pencil sketches. Moleskine makes sketchbooks with watercolor paper that open out into a landscape format, which are designed for outdoor painting.

OTHER USEFUL MATERIALS

Pencils are essential for creating an initial sketch, and can also be used to add more detail to a dry painting. I would recommend using a medium-softness pencil to sketch with watercolors; this is usually a number 2 pencil in the United States and an HB in other countries. A very soft pencil might smudge and make your colors look gray. You will need a couple of good-quality erasers in your kit to rub out pencil sketches. A cheap eraser can smudge the pencil and leave a dirty mark. One soft and one hard eraser is plenty.

I love to use water-soluble colored pencils in my work. They are great for

lightly sketching out a picture, as the pencil lines disappear when painted over. They are also great for adding more detail, depth, and interest to an image and highlighting the texture of the paper. I recommend using good-quality water-soluble pencils, rather than cheap children's pencils. I have a large selection of colored pencils, which includes about twelve varieties of the color brown! You can buy a set or just the individual colors that you need.

I don't often use pens in my work, but they are useful to have in your kit. The most important thing when using pens with watercolor is that they are waterproof. You can draw the pen outlines first and then fill in the picture with watercolor, or use pens on top of the dry painting (make sure the painting is completely dry, as using pens on a wet surface will ruin them). Look for good-quality waterproof fine-liners in a variety of sizes. You can also buy brush pens that come with waterproof ink, which can add an interesting variation to your line work. White gel pens can be useful for adding white highlights and details to work.

You can buy watercolor pens that are blendable on paper, but I have never seen the point of them myself. To me, the joy of watercolors is having a small set of twelve colors and being able to make any color you want, rather than having 100 watercolor marker pens and still not having the color you want.

Masking fluid is a useful addition to any watercolorist's kit. It is a thick waterproof gel that is applied to the paper in order to leave an area protected from the watercolor. When it's dry, you paint over the paper as normal, then peel off the masking fluid to reveal the white paper underneath. Masking fluid is very useful for maintaining small areas of

white paper within a dark background. By painting straight over the masking fluid, you get an even flow of watercolor on the paper, rather than painting around the space. Masking fluid can be applied with a brush or plastic spreading tool. The masking fluid ruins brushes, so I would recommend using an old or cheap brush.

You will need a pot of water for washing your brushes and diluting the paint. It doesn't need to be anything fancy: an old jam jar will do. When changing colors, wash the brush each time to avoid contaminating the color in the pans.

I always suggest going for the middle range in both price and quality when it comes to buying art materials as a beginner. Generally, with art materials you get what you pay for. If the price of a set of paint or brushes seems too good to be true, the quality probably won't be great. The quality of materials isn't everything, but you will struggle if you are using a very cheap children's watercolor set. Some people suggest always buying the very best materials, but I think it's a good idea to have a range of different paints, papers, and brushes, especially when you're first learning. It's good to try a few different brands to find out what you like. I also find that very expensive materials can be intimidating. When you're first learning to paint, the thought of ruining a beautiful piece of 100 percent cotton rag mold-made paper is terrifying. I think it's a good idea to have a collection of papers in different textures and also different prices.

On the other hand, if luxurious materials inspire you, treat yourself. The most important thing to remember is that good materials will only take you so far: you need to put in the time and practice to really progress.

Your Workspace

It's important to find a workspace where you feel comfortable physically and emotionally, although you shouldn't be put off painting if you don't have a proper studio. One of the great things about watercolors is that they really don't take up much space and don't need a lot of specialized equipment. I have a lot of materials on my desk, but when painting on location I pare it back to the essentials: a box of watercolors, a couple of brushes, a pencil, a small sketch pad, and some water.

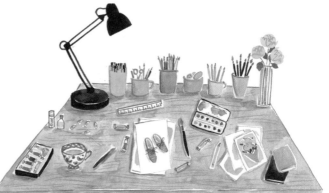

A large desk in a well-lit room is perfect for watercolor painting, but a dining room table will do the job as well. I wouldn't recommend painting watercolor sitting on the couch or on the floor. Wet watercolors run very easily, which means your paper needs to be flat on a table when you're working. It's preferable to have a dedicated desk space that you can keep your materials arranged on at all times. My desk setup includes a desk lamp for working on cloudy days and in the evenings, a pot of scissors and craft knives, a pot of colored pencils, a pot of graphite pencils, a large pot of paint brushes, a small pot of various erasers, a pot of pens, a selection of paint palettes, a box of watercolors, tubes of watercolors, paperclips, glue, masking fluid, a pencil sharpener, a pot of water for brush washing, washi tape, and a vase of fresh flowers. I also have a scanner, a computer, and a graphics tablet for digitizing my work.

I like having all my materials easily at hand when I'm working. Jam jars and ceramic tumblers or mugs make great containers for art materials. If you have the space, keep your brushes, pencils, and pens all in separate pots so it's easy

to find what you're looking for. I also have shelving and storage units nearby to hold additional materials and to store completed sketchbooks and artwork. If you don't have a designated desk space and work at a dining room or dressing table, create an art cupboard in which to store all your materials safely. It is important that your chair is supportive and is an appropriate height to the table so that you don't hurt your back or neck if you're painting for a long time. Try not to stoop over your desk too much and keep your feet flat on the floor whilst sitting. Make your desk a cozy and inspiring space with fresh flowers, artwork on the walls, and your favorite art books at hand.

Fear of the Blank Page

Fear of the blank page is something that even seasoned artists experience. It takes a kind of bravery to create something from nothing, as any expression of yourself can make you feel vulnerable. The blank page can be daunting, but a painting must be approached with confidence. A confident brushstroke looks very different from an unsure one. The best way to learn to paint with watercolor is not to be precious about your work and to experiment with confidence. Watercolors work best when there isn't too much fussing and fiddling with the image. Often the most important thing is learning when to stop. Learning to use watercolor helps you learn to be confident in your ability to make creative decisions. Here are some ways that I, and other artists, have found to deal with these feelings.

Often artists worry about wasting expensive materials. I would recommend having a variety of papers to paint on, including both cheap cartridge paper and expensive watercolor paper. If you are using a less expensive paper, you are less likely to worry about wasting or ruining it. Being able to loosen up and relax whilst painting is just as important as the quality of the materials. Working

at a small scale can also help artists loosen up. I personally prefer to work at the 6 x 8-inch size, but you could keep a postcard-size sketch pad for trying out new ideas and techniques.

Watercolors benefit from efficiency and speed, but when you're feeling anxious it's easy to overwork a painting and spend hours deliberating over it. Try settling on a subject and give yourself a time limit—for example, 30 minutes to paint a single flower.

A student I taught once told me that the best thing she did for herself as an artist was to pick up lots of off-cuts from a local printer. The card came in all sorts of shapes and sizes, and she did a painting on one of these off-cuts every evening. Because these were off-cuts originally destined for the trash, there was absolutely no pressure, and the regular habit of practicing every day greatly improved her work.

It's important to feel comfortable in the place that you're working. I love painting on location, in museums, and on vacation, but this could easily be intimidating to some. Make yourself comfortable at your desk or painting table, have a cup of tea, put on some nice music or the radio, and make sure you feel at ease before you begin painting.

Notes on Using This Book

Most of the paintings in this book were created on a small scale; this is just the way I prefer to work. I would recommend using either 6 x 8-inch or 8 x 10-inch watercolor paper. I have used watercolor paper with a weight of 140 pounds throughout the book, unless otherwise stated.

Throughout the book, I refer to small, medium, and large brushes. You can get away with just three brushes and be able to paint all the projects in this book, but it is nice to have a few brushes of each size, as then you won't be constantly washing and changing brushes. The projects in this book can be painted with

either sable or good-quality synthetic brushes. It is entirely your decision which you prefer to use.

On page 26 you will see a color chart that shows the twenty colors used in this book. I would recommend buying a set of paints that contains as many of these as possible—however, each set of paints is different, and manufacturers choose their own selection of paints to include. Because of this, each project has its own set of color swatches, which allows you to match the paint you already have as closely as you can to the colors used in the project. Many of the colors used have subtly different matches that can be swapped without it being very noticeable. For example, alizarin crimson can be substituted for permanent carmine or permanent rose, and phthalo green can be substituted for viridian green. Matching the colors you already have in your set as closely as possible to the ones on the swatches is a great way to develop your eye and learn to identify the undertones of colors. Do bear in mind that the exact formulation of colors will vary from brand to brand, so there may be subtle differences even in paints with the same name.

Most of all, remember to have fun, and that everything you do is part of the learning process, whether it turns out how you expected or not. Don't worry about wasted paper or paint: if you've learned something from it, nothing is wasted.

This isn't a very traditional watercolor book, and that worried me slightly whilst writing it. What would the traditionalists say if they read it? But the truth is I'm not writing it for them: I'm writing it for you. I have a relaxed approach to both my paintings and my materials, and hopefully by reading this book my relaxed approach will rub off on you. Whether you're painting as a hobby or part of your business, I want you to enjoy it. If you're looking for something traditional, then there are hundreds of books out there that will probably suit

you. If you're looking for something a little bit more joyful, then you've found the right book.

Color Theory

There are three primary colors (red, yellow, and blue) and three secondary colors (orange, green, and purple). The secondary colors are made by mixing two of the primary colors together. Primary colors cannot be made by mixing any other colors together. Each primary color has an opposite secondary color. Red is opposite to green, blue is opposite to orange, and yellow is opposite to purple. A pair of colors are opposite to each other because the primary color is not used to mix the secondary color;

for example, red is not used to mix green. On the color wheel, the color that falls directly opposite each other is its opposite color. Opposite colors are also sometimes called complementary colors, as they complement each other well when used in an image.

Each of the primary and secondary colors have many different varieties. On the chart on page 26 I show all the colors I will be using in this book, along with the undertone of each color. Knowing the undertone of a color will help you predict how it will mix with other colors. Red and blue will usually make purple, but if you try mixing cadmium red pale with cerulean blue, you will get a brownish gray. The reason for this is that the undertone of cadmium red pale is yellow, and the undertone of cerulean blue is green—and yellow and green don't belong in purple. If you mix alizarin crimson with ultramarine blue, you will get a bright, clear purple. This is because the undertone of alizarin crimson is

Undertones

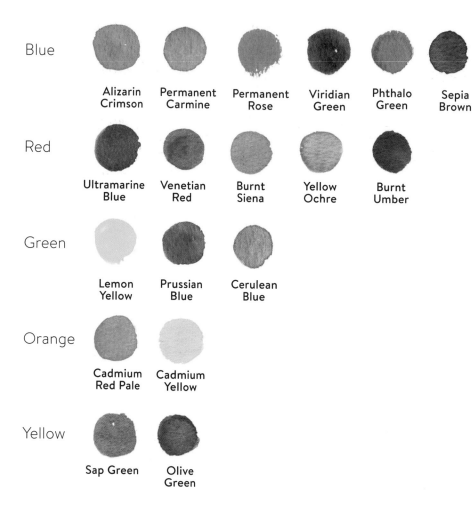

Blue

Alizarin Crimson — Permanent Carmine — Permanent Rose — Viridian Green — Phthalo Green — Sepia Brown — Lamp Black

Red

Ultramarine Blue — Venetian Red — Burnt Siena — Yellow Ochre — Burnt Umber

Green

Lemon Yellow — Prussian Blue — Cerulean Blue

Orange

Cadmium Red Pale — Cadmium Yellow

Yellow

Sap Green — Olive Green

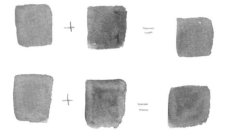

blue, and the undertone of ultramarine blue is red, which are both colors you would expect to find in purple. When the undertones match up with the color you're trying to mix, it creates a bright color, and when the undertones don't match with the color you're trying to mix, it creates a more muted color.

By knowing the undertones of the colors in your palette, you can predict how they will mix. For example, if I wanted to make olive green lighter and brighter, I would add lemon yellow, but if

I wanted to make it lighter and earthier, I would add yellow ocher. To bring out the blue tones I would add ultramarine blue; to make it a dark, complex green I would add permanent carmine. To make it darker and cooler I would add black, and to make it a brownish green I would add Venetian red.

Making color charts is a good way to get to know your color palette. Here I've shown how mixing permanent carmine with other colors in your palette can produce beautiful and unexpected results. For example, mixing permanent carmine, which is a blue-toned red, with phthalo green, which is a blue-toned green, will make some lovely purples and berry colors. Black has a natural blue

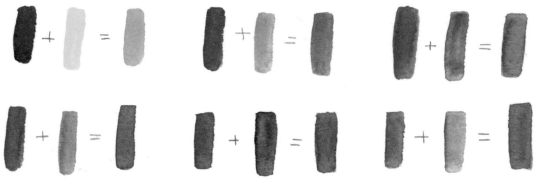

undertone and will also create subtle purples when mixed with permanent carmine. Making charts like these—exploring how colors in your palette mix with each other—shows you the broad potential of each and every color.

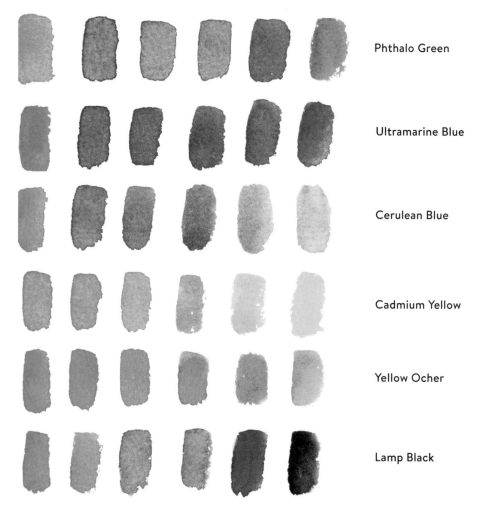

Phthalo Green

Ultramarine Blue

Cerulean Blue

Cadmium Yellow

Yellow Ocher

Lamp Black

COLOR-MIXING EXERCISE

YOU WILL NEED Selection of colors of your choice (four to eight colors is ideal) · Medium or large brush · Thick watercolor paper

Experiment by creating loose circles and ovals of different paint mixes. Allow the shapes to touch each other and see how the wet paint flows from one into another. Notice the difference in how the paint flows between two very wet shapes, and between one wet and one almost-dry shape. There is no right and wrong here: just experiment and get used to the feel of the brush in your hand, the paint on the paper, and the way the colors interact and their drying times.

You might notice a difference in the way dark and light colors blend when they are wet. Paint a square using permanent carmine, and whilst it's still wet, paint a square of phthalo green next to it, just touching it (fig. 1). Observe how the green blends with the wet paint already there. Paint another square using permanent carmine, and whilst it's still wet, paint a square of watery cadmium red pale just touching it (fig. 2). Notice how this lighter, more watery color spreads differently. The higher concentration of water means that as it flows into the permanent carmine, it disrupts the pigment already there.

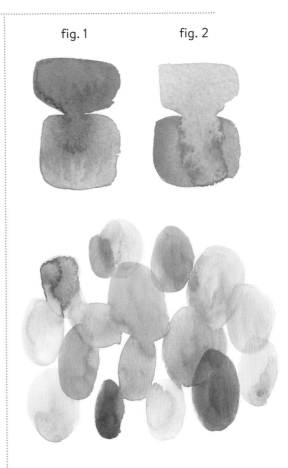

fig. 1 fig. 2

Color Inspiration

When you're first starting out, it's tempting to use all the colors at once, but this can make a painting look too busy and unbalanced. It takes a while to learn how to use colors in a sophisticated, nuanced way. Everyone has their own personal color palette: some people like bright colors, and others love pastels or rich jewel tones.

I always keep an eye out for pleasing color combinations. I spot beautiful unusual combinations all the time, from tiles on the subway to cereal bowls in the drying rack. A good way to collect inspiration is to look at a favorite photo or painting and try to identify the main colors.

LIMITED COLOR PALETTE

I often use a limited color palette in my work. I might choose two or three main colors and then pick one as an accent color, and use those same colors throughout the painting, using the accent color to add small details that bring the painting to life. Challenging yourself to use a limited color palette is a great exercise. When you're choosing your colors, think about the mood they create; are they muted and somber, bright and lively, rich and autumnal?

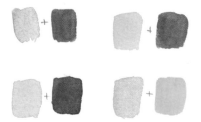

I often use opposite colors in my work. It's rare that I would use a bright green and a bright red next to each other, but I often use pink with various shades of green. Pale mint, olive green, and emerald all look great contrasted with fuchsia, salmon, or baby pink. Purple and yellow is another great combination. I like to combine rich mustard yellow with deep burgundy purple. Blue works well with orange, peaches, and rust colors. When

I am putting together a color palette for a painting, I always think about opposite colors. If a painting is predominantly green, I think about how I can add some small touches of red or pink to balance it. You don't have to use opposite colors in every painting, but it is a good place to start when deciding which colors to use. These are some of my favorite color combinations that I like to use in my work: mustard and maroon, pale peach and navy blue, baby pink and dark green, and pale gray and rich yellow.

Basic Techniques

The first step of creating a watercolor painting is to mix paint, from a tube or a pan, with water and then apply it to the paper with a brush: what you do with it can be any number of basic techniques.

If you are right-handed, you should always work from left to right when you're painting a picture to avoid smudging it. If you are left-handed, work from the right to left.

CREATING A WASH

A watercolor wash is when you apply paint evenly to a large area of the paper. To create a wash, load a large brush with plenty of watery paint and sweep it across the paper horizontally, working the brush back and forth down the page. As you work down the page, the color will gradually get lighter as the pigment runs out (fig. 1). To create a wash of flat color, keep adding more paint of the same consistency. To create an ombré effect, make the paint mixture increasingly watery as you work down the page (fig. 2). The size of your brush should correspond to the size of the area of paper you are trying to cover. It will be difficult to create a large, even wash with a small brush. When you are using pans of watercolors, gently use the brush to

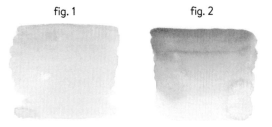

fig. 1 fig. 2

pick up the pigment, moving the brush from side to side and keeping the bristles pointing in the right direction. Don't mix the paint with too much force, which could cause the bristles to splay out in the wrong direction. This will ruin your brush. The better you look after your paintbrushes, the longer they will last.

MIXING DIFFERENT TONES OF THE SAME COLOR

An important part of learning to paint with watercolors is learning to control the amount of water used and how it will affect the end result. Many different tones can be created from a single pigment by varying the amount of water that it is mixed with. The more water added the paler the color will be; the less water added the more intense the color will be. It is important to understand the difference between *tone* and *hue*. *Hue* describes the color itself, and *tone* describes how light or dark it is. You could create many different tones of

the same hue by adding more or less water to it on the palette. As well as your painting having a variety of colors, it is important that it also has a variety of tonal values. Imagine if you took a black-and-white photo of your painting—would you produce an image with contrasting areas of light and dark, or would you produce a painting that was all one tone of gray? A good way to check if your painting needs a bigger variety of tonal values is to squint your eyes, which helps you see the basic areas of light and dark, and not focus too much on the detail. A few details in a dark color added at the end of the painting can bring the whole thing to life and add much-needed contrast and definition. Using a palette with multiple wells can help you mix up several different tones of the same color. The example shows how increasing amounts of water have been added to alizarin crimson to produce a variety of tones.

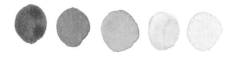

USING WHITE

Using white when painting with watercolors produces some interesting effects and can be useful. In this example, the exact same colors were used to paint both flowers. In the first example the petals were painted with permanent carmine, the head of the flower with Venetian red, and the stem with olive green (fig. 1). In the second example the exact same colors were used, but Chinese white was mixed in (fig. 2). The addition of white makes the colors more even and opaque, but it also causes them to look paler, which can be useful for achieving pastel colors. However, by contrast, the colors in the first flower appear much more vibrant with a lot of variety in tone.

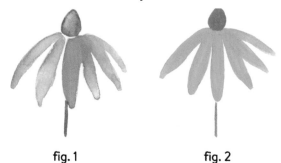

fig. 1 fig. 2

Layering Colors
WET-ON-DRY TECHNIQUE

The wet-on-dry technique means a layer of paint is applied over an existing layer of paint that has dried. This technique allows you to add depth, details, and definition to a painting. The second layer of paint will be distinct and crisp as long as you wait until the first layer is completely dry. The thing that makes watercolors unique is their transparency. By creating two circles of different colors using the wet-on-dry technique, you create a third color where they overlap. If the two circles are the same color, the overlap will be a darker version of that color. It is possible to paint a dark color over a light color, but a light color—for example, a pale yellow—painted over a dark color will be very difficult to see.

WET-ON-WET TECHNIQUE

The wet-on-wet technique means a layer of paint is applied over an existing layer of wet paint. The second layer

of paint will blend into the first layer with no defined edges or brushstrokes. This technique is great for depicting subtle color changes. By creating two overlapping circles of different colors using the wet-on-wet technique, you can see how they blend into each other. My second example shows you the huge difference when detail is added to a dry wash of paint and to a wet wash of paint. In the example using the wet-on-dry technique, the lines are clear and defined; in the example using the wet-on-wet technique, the lines are soft and diffused.

wet on dry

wet on wet

wet on dry

wet on wet

GENERAL TIPS

A careful balance of pigment and water is needed to create intense layers of color that are still wet enough to move easily across the paper. A wetter mixture of paint will take longer to dry than a mixture made with less water. It's important with watery washes of paint not to touch the paint accidentally whilst it is still wet. Touching the paint with a brush or your hand will lift the pigment off the paper and leave a pale mark. It's very difficult to add more pigment and make the painted surface as even as it once was. This does mean that wet paint can be lifted from the surface of the paper, which can be a useful technique. For example, you could paint a large blue wash of sky, then use a dry brush or piece of tissue to pick up pigment and create the effect of clouds. This also means that if you make a mistake, you can use a clean wet brush to wash away the paint and a clean tissue to blot it. The paint will often leave a very subtle stain on the

paper, but once it is completely dry you should be able to paint over it without it being noticeable.

The first way to tell if a wash is still wet is to tilt the paper slightly; if the surface catches the light, then the paint is still wet. If the surface doesn't catch the light, you can touch it gently to see if it still feels damp. If it doesn't feel damp, it's dry enough to work over. If the area you have painted has a ring of pigment around it when it is dry, you have probably used too much water. If there is a bubble of water on the surface of the paper, it will flow out to the edges as it dries, rather than drying evenly. As you practice painting you will get used to the drying times of the paint. When painting quickly—for example, on location—I often deliberately leave small gaps of white paper in between colors so that I don't have to wait for each individual color to dry before starting the next. This technique also adds a freshness and vibrancy to your work.

PAINTING FLOWERS

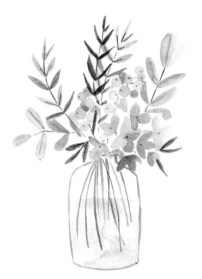

Flowers make a great subject for watercolorists of all levels, as they are familiar, beautiful, and endlessly inspiring. They come in a huge variety of shapes, textures, and colors, making them the perfect subject for a painting. Watercolors are ideal for capturing the subtle blending of colors and tonal varieties we see in flower petals.

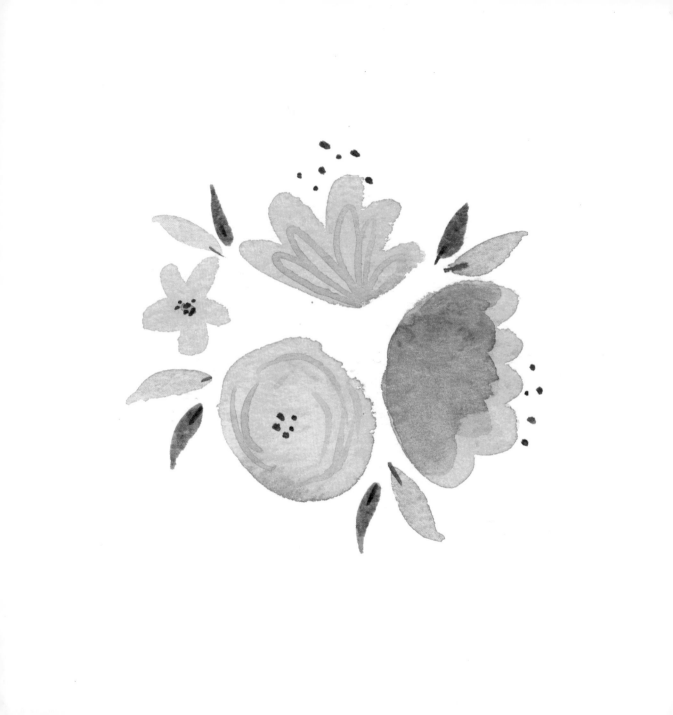

SIMPLE FLOWERS

BEGINNER

These very simple flowers will help you master some more basic brushstrokes, as well as adding detail using different tones of the same color.

YOU WILL NEED Medium round brush · Small round brush · Watercolor paper, about 8 x 10 inches

COLORS Alizarin crimson ● Sap green ● Burnt umber ● Viridian green ● Sepia brown ●

First, using a watery mixture of alizarin crimson and your medium brush, paint four flowers. To create the circle, swirl your brush around in a spiral shape. To create the other flowers, work your brush backward and forward, rotating the paper as you go to create a fan shape.

Whilst that is drying, add a few simple leaves to each side using your small brush and a mixture of sap green and burnt umber, and viridian green and alizarin crimson. Once those are dry, add some simple details to your flowers using a darker shade of alizarin crimson and your small brush. Once that is dry, add centers to the flowers with sepia brown and your small brush. (See opposite page.)

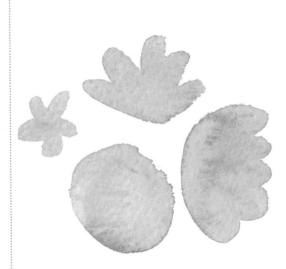

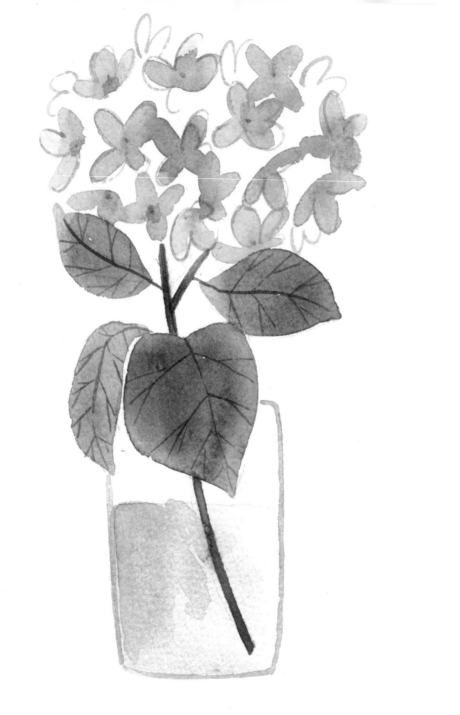

BLUE HYDRANGEAS

BEGINNER

The natural blending of colors in hydrangeas makes them the perfect subject for practicing the wet-on-wet technique. Wet-on-wet painting uses two different colors of wet paint applied one after the other, giving the wet paint a chance to blend and mingle. I have painted blue and green hydrangeas, but you can paint any colors you like; blue and purple or pink and green would also work well.

YOU WILL NEED Large round brush · Medium round brush · Small round brush
Watercolor paper, about 8 x 10 inches · Pencil

COLORS Cerulean blue ● Prussian blue ● Olive green ●
Permanent carmine ● Sepia brown ●

Sketch out the vase and the leaves with your pencil, leaving space for the flowers. Using a medium brush, paint the flowers using a watery mixture of cerulean blue. Whilst it is still wet, add a touch of Prussian blue and olive green. Use the very tip of your brush to add the extra pigment to the wet paper and watch the color spread.

Mix olive green, Prussian blue, and a tiny bit of permanent carmine to make the color for the leaves. Paint the leaves using your large brush, allowing color to pool in certain areas.

Add more permanent carmine to the green mixture to make it darker (add this color very carefully, as a little bit can have a big impact). Once the leaves are dry, add veins and stems using the darker green and your small brush.

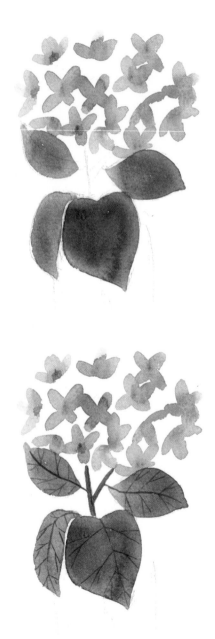

Once the flowers are dry, add centers and very loose outlines using cerulean blue and your small brush. Outline the glass vase in sepia brown using your small brush. Add a watery wash of sepia brown to the bottom half of the vase for water using your large brush.

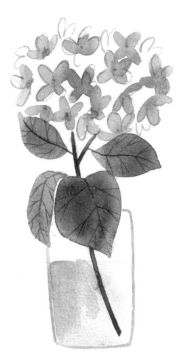

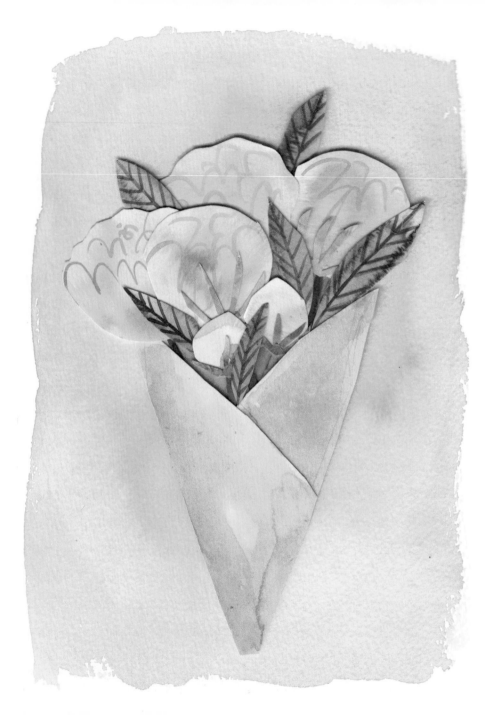

PAPER PEONIES

Creating cut-paper collages using pre-painted sheets is a fun way to experiment with the textures of watercolor and create some interesting effects. This effect can be applied to many different subjects. Cartridge paper comes in varying weights; always use the heaviest weight available when using it with watercolors.

YOU WILL NEED Large round brush · Medium round brush · Small round brush ·Heavy-weight cartridge paper, about 8 x 10 inches · Watercolor paper, about 8 x 10 inches ·Craft scissors · Glue stick

COLORS Permanent carmine ● Olive green ● Ultramarine blue ● Burnt umber ● Yellow ocher ● Cadmium yellow ●

You will work on cartridge paper for this, as thick watercolor paper will be difficult to cut and glue.

With a large brush, paint a section of the cartridge paper with a watery mix of permanent carmine, swirling the brush to create as much variation and texture as possible. Create a mixture of olive green, ultramarine blue, and burnt umber and use the large brush to paint a section of the paper for the leaves and stems. Run a wet, clean brush through the painted section for the leaves to create lots of variety of tone. Add more burnt umber and ultramarine blue to the mix to create a darker green.

Paint two broad lines with your large brush and the darker green to be used as stems.

Using a large brush and a mixture of yellow ocher and burnt umber, paint the brown paper to hold the bouquet. If you prefer, you could paint a vase or a bucket for the flowers instead.

Once the paper is completely dry, cut rough circles out of the pink area, long pointed leaves and stems from the green sections, and triangular shapes from the brown paper.

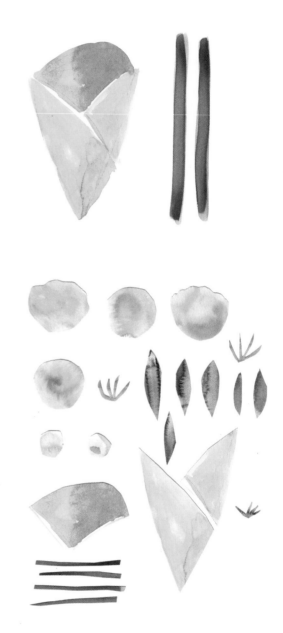

Using your small brush, add more detail to the peonies and leaves. I used a slightly darker shade of permanent carmine to add petal detailing to the peonies, and a darker mix of olive green, burnt umber, and ultramarine blue to paint the veins on the leaves.

When everything is dry, arrange the pieces together. The separate pieces of paper allow you to play around with the composition. When you're happy with the composition, glue the pieces together.

Mount the finished bouquet on a piece of watercolor paper with a painted colored background (I used cadmium yellow) using a glue stick.

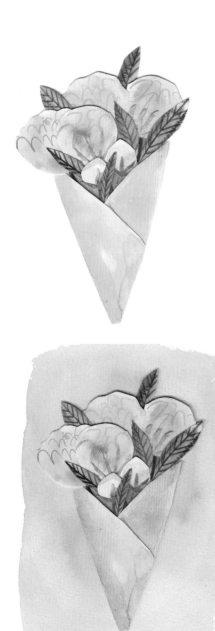

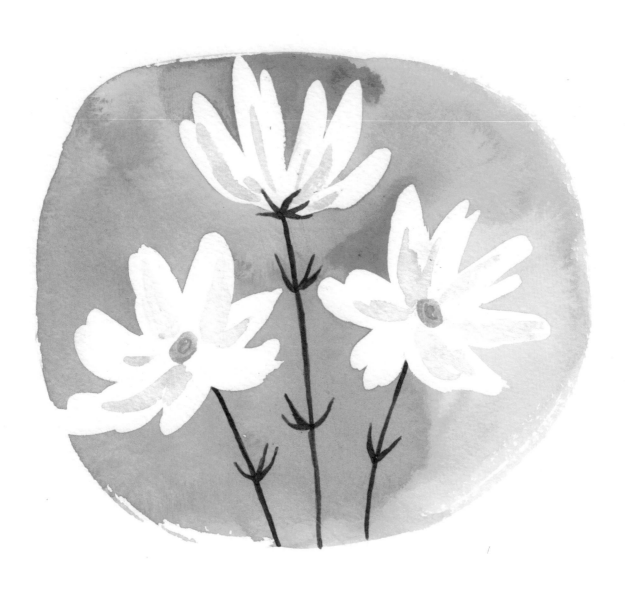

WHITE COSMOS

BEGINNER

Painting a white object on a white piece of paper is always a challenge, and there are several different ways to approach it. You could outline the object or use shadows to define it. In this lesson I will be using a colored background and negative space to paint three white flowers, using masking fluid to help me. For research look at white flowers such as anemones, cosmos, and daisies, noticing how shadows fall across the white petals and the hints of pink and purple at the center. Also notice how the petals appear longer or shorter depending on their direction.

YOU WILL NEED Large round brush · Small round brush · Medium old brush for applying masking fluid · Watercolor paper, about 8 x 10 inches · Masking fluid · Pencil · Eraser · Tissue

COLORS Permanent rose ● Cadmium yellow ○ Yellow ocher ●
Sap green ● Olive green ● Cadmium red pale ●

Start by very lightly sketching out three flowers with your pencil. Apply masking fluid using an old brush over the area of the paper that is going to stay white.

Once the masking fluid is completely dry, apply a background wash of permanent rose (or another bright color of your choice) using a large brush. The area covered in masking fluid will be resistant to the paint, so you can paint right over it, giving an even, continuous wash of color. Work quickly whilst the paint is still wet. If you stop halfway through and go back to it when the paint is dry, it will be difficult to continue without creating a noticeable overlap of paint. The masking fluid will leave the shape of the flowers in white. This white space is called the negative space.

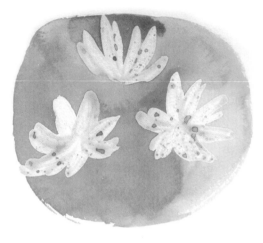

Once the background wash is completely dry, carefully peel off the masking fluid; it should come off in a thin rubbery sheet. Rub off the pencil guidelines with a soft eraser.

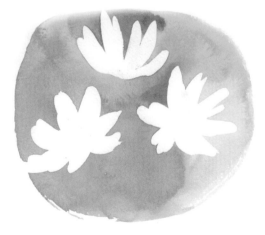

Using a small brush, paint the stalks using olive green. Paint a circle of cadmium yellow using your small brush for the centers, then add yellow ocher and sap green on top to add definition.

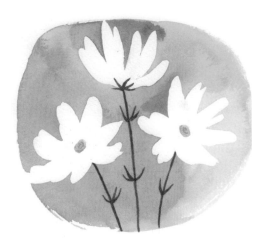

Very loosely add areas of shadow to the white flowers. I made a shadowy color by mixing equal parts sap green and cadmium red pale. You could use watered-down black paint, but that would give a less subtle effect. If the shadows look too dark, you can always blot them quickly with a tissue whilst they are still wet. You want it to look organic and not too perfect.

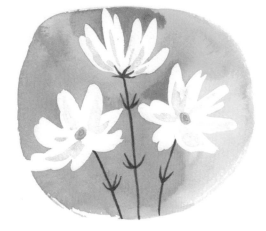

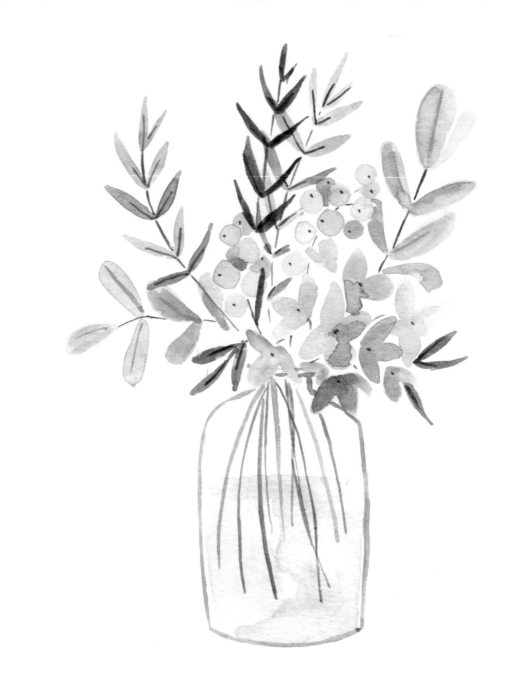

AUTUMNAL FLOWERS

BEGINNER

This painting uses a cool, muted palette and subtle variations in color. This piece will allow you to practice the wet-on-wet technique for both the hydrangeas and the snowberries.

Flowers are a great thing to paint when you first start learning watercolors because they allow you to practice mixing lots of different colors and paint lots of different shapes and textures. Watercolor lends itself very naturally to painting flowers because the transparent quality of the paint is ideal for capturing translucent petals and leaves.

YOU WILL NEED Large round brush · Medium round brush · Small round brush

Watercolor paper, about 8 x 10 inches · Pencil · Eraser

COLORS Viridian green ● Ultramarine blue ● Alizarin crimson ●

Sap green ● Burnt umber ● Cadmium red pale ●

Start by sketching out the floral arrangement very lightly with your pencil. You don't need to sketch every single leaf; just get a rough idea of the layout. Create a watery mixture of viridian green, ultramarine blue, and a tiny bit of alizarin crimson. Paint the rounded eucalyptus leaves with this mixture using a large brush. Paint the thinner leaves with a mixture of sap green, ultramarine blue, and burnt umber using a medium brush. Make sure the leaves don't look too uniform; vary the intensity of color and the angle of the leaves to make them look more natural.

Using the same color mix as the eucalyptus leaves, start to paint the hydrangeas using a medium brush, allowing the color to pool in different areas. Mix a purple using ultramarine blue and alizarin crimson and paint several purple flowers and leaves, allowing this color to bleed into some of the blue flowers. You need to work quickly at this point so that the colors blend whilst they are still wet. Using a more intense mixture of alizarin crimson and ultramarine blue, paint the stalks of the leaves using a small brush.

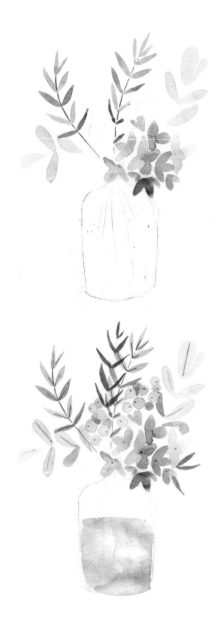

Use watery washes of alizarin crimson and sap green and a medium brush to paint the snowberries, again working quickly whilst the paint is still wet to let the green and pink blend into each other. When they are dry, use the dark purple color and your small brush to add dots to the snowberries and hydrangeas.

Mix a darker shade of green using sap green, ultramarine blue, and burnt umber and use it to add detail to the leaves using a small brush. Add more of the thinner leaves to the foreground using this darker green, allowing the leaves to overlap the other elements of the painting. This adds a sense of depth.

Using a watery mix of sap green, ultramarine

blue, and cadmium red pale, paint the water in the jar with a large brush. Allow the wash to pool randomly in some areas to add depth.

Add more ultramarine blue to the water-colored mix and outline the glass bottle with a small brush. With your small brush, paint the stalks using the colors you've already mixed earlier in the painting: use the mixture of sap green, ultramarine blue, and burnt umber from the dark green leaves; the alizarin crimson and ultramarine blue mix from the dark purple flowers; the viridian green, ultramarine blue, and alizarin crimson mix from the eucalyptus leaves; and the sap green, ultramarine blue, and cadmium red pale mix from the glass bottle. Allow the stalks to bend and overlap naturally. Add more leaves or details to make the arrangement feel natural and balanced. When it's completely dry, rub out any pencil marks with an eraser.

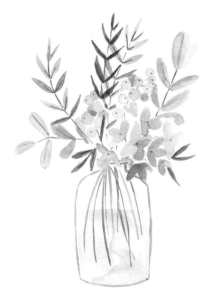

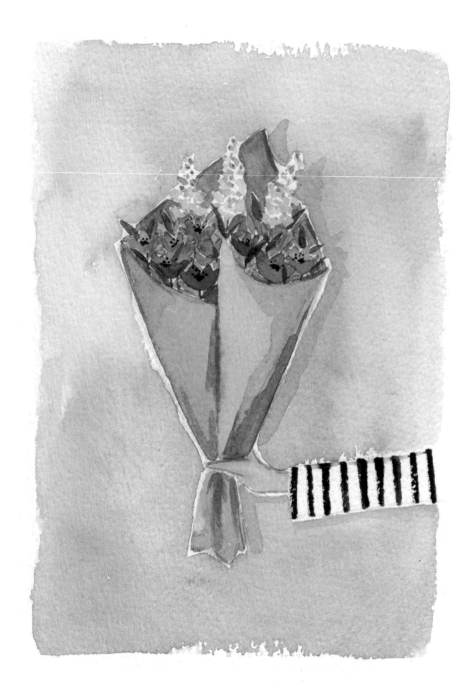

FLOWERS IN BROWN PAPER

This floral image is slightly more complicated than the ones we have tackled so far, as it involves colored backgrounds, shadows, and perspective, but it is important to challenge yourself as you grow in skills and confidence.

YOU WILL NEED Large round brush · Medium round brush · Small round brush · Watercolor paper, about 8 x 10 inches · Pencil

COLORS Permanent carmine ● Prussian blue ● Cadmium red pale ● Sap green ●
Olive green ● Sepia brown ● Yellow ocher ● Lamp black ● Burnt sienna ● Chinese white ○

Very lightly sketch out the flowers in the paper and the hand holding them with your pencil. Using a mix of permanent carmine and Prussian blue, paint the anemones (the purplish flowers in front) using a small brush. The anemones look like upside-down umbrellas. Vary the shade of purple as you paint them. Paint the stocks using cadmium red pale and sap green, using small dabs of watered-down paint and your small brush. The stocks start green at the top and become pink as they go down.

Paint the leaves with your small brush and a mixture of olive green and Prussian blue. Vary the direction and tone of the leaves.

Once the leaves are dry, use a mixture of sepia brown and yellow ocher and your medium brush to paint the brown paper. Add more sepia brown to the paper behind the flowers, as it would be darker and more in shadow. Don't worry if there are little bits of white space around the flowers. That is fine. It keeps it looking light and fresh. Once the brown paper is completely dry, paint the background using a mixture of Prussian blue and permanent carmine with your large brush. Allow the color to pool in different areas to vary the tone of the background, and highlight the texture of the paper by leaving rough edges. Rough edges, texture, and white spaces all add layers to your painting. Using sepia brown, add some shadows and definition to the brown paper with your small brush.

Add centers to the anemones and stripes to the sleeve using lamp black and your small brush. I didn't use very much water so that the stripes would have a dry texture. Mix burnt sienna and Chinese white to make the skin tone (see page 153 for tips on mixing different skin tones) and use it to paint the hand with your small brush.

Using your medium brush, add another layer of the purple color to the background to add shadow behind the flowers. Add detail to the hand using burnt sienna and your small brush.

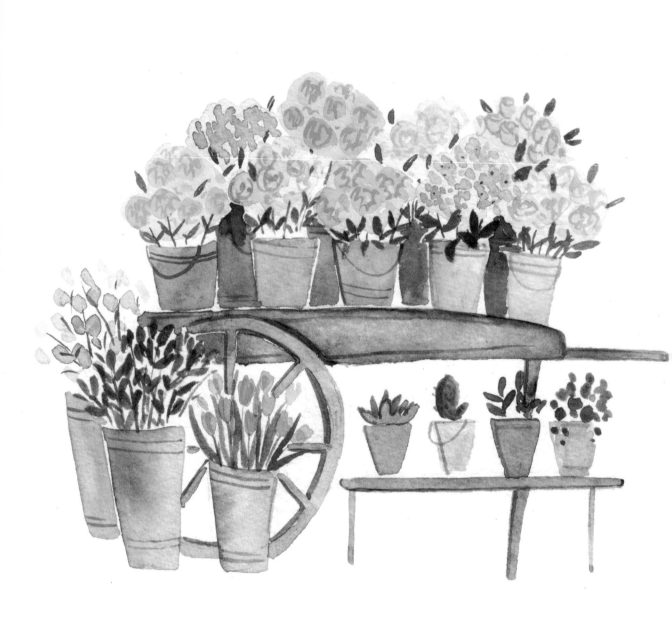

FLOWER STALL

This is the most challenging lesson we've tackled yet, as it is a complex composition involving a variety of objects. The important thing here is to take it slowly and follow the instructions carefully, adding everything in the right order. Building a painting layer by layer is very important when it is as complex as this. Because there are many elements to the scene, I have kept the colors fairly simple, with light shades of pink, blue, and green. You can paint the flowers any color you want, but be careful of having too many bright colors next to each other, which can make the painting feel too busy.

YOU WILL NEED Large round brush · Medium round brush · Small round brush · Watercolor paper, about 8 x 10 inches · Pencil

COLORS Cadmium red pale ● Permanent carmine ● Sap green ●
Ultramarine blue ● Phthalo green ● Sepia brown ● Lamp black ●

Start by lightly sketching out the cart, bench, and buckets of flowers. Use a hard pencil and sketch as lightly as possible; you want to avoid too many pencil marks on the paper, which could smudge and make everything look a bit gray. Using a medium brush, create very light washes of colors to indicate where the flowers are. I have used cadmium red pale, permanent carmine, sap green, ultramarine blue, and a purple made with ultramarine blue and permanent carmine. These washes should be very pale and cloudlike in shape. Using a small brush, paint the tulips in the foreground with cadmium red pale.

Mix up several shades of green using a mixture of phthalo green and permanent carmine, and sap green and sepia brown. Paint the stems and leaves of the flowers in the buckets, including the tulips, using your small brush. Paint eucalyptus leaves using a watery mixture of phthalo green and permanent carmine: paint small light circles, then add stems in a darker shade. When that is dry, paint the foliage in the bucket below using a mixture of sap green and sepia brown and your small brush. Vary the amount of sepia brown in the mix to create leaves in a variety of shades. Using those two green mixtures, paint simple cacti and plants in the small pots on the bench. Vary the colors by adding more water or more sepia brown.

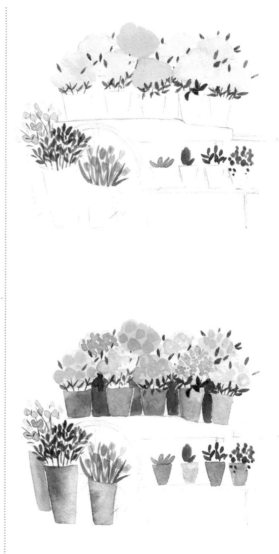

Create watery mixes of both lamp black and sepia brown and paint the buckets using a large brush, alternating between the colors. Use a more-watered-down mixture of paint for the buckets in the foreground and a darker mix for the buckets in the background, to give a sense of perspective.

Once the buckets are dry, add some details to the flowers using a small brush. I have used a darker version of a flower bunch's original color to add blooms and petals to create individual flowers. For the hydrangeas, use a mixture of ultramarine blue and permanent carmine and add loose dabs of color indicating petals. For the roses and peonies, paint loose circles in perma-

nent carmine or cadmium red pale. For the green flowers, add detail using a very light mix of cadmium red pale. Also use cadmium red pale to add shadows and detail to the tulips.

Using your small brush, add some detail to the cacti and simple plants using the same shades of green as before. Add shadows, extra leaves, and spikes. Once the flowers are dry, define the petals even further using a small brush. Use a slightly darker shade of cadmium red pale or permanent carmine to paint swirls in the center of the roses and wavy lines to indicate petals on the peonies.

Using your small brush, add handles and detailing to the buckets, using either lamp black or sepia brown as appropriate. Create a mixture of phthalo green and lamp black and paint the cart using a medium brush. Paint the wheel using a slightly lighter shade of the mixture to give a sense of perspective. Paint the bench using sepia brown.

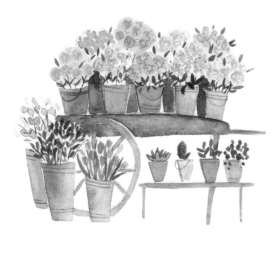

When that is dry, use your small brush to add shadows inside the wheel using the same green/black mix to add depth. Adding a second layer of the same color creates a darker area, as there is now twice as much pigment on the paper. Add outlines to the edge of the cart using the same green/black mix. Add a line of shadow to the bench using your small brush and sepia brown.

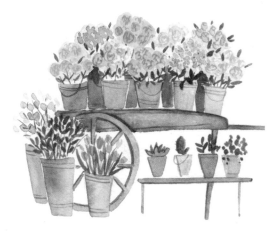

PAINTING
FRUIT

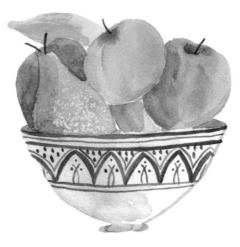

Fruit can seem like a fairly obvious starting point for an amateur watercolorist. In this section we will look beyond the classic still life bowl of fruit, also tackling sliced tropical fruit and a vibrant fruit market. By studying tropical fruit, you have the chance to explore some of the bolder and brighter colors in your paint palette, and to use a variety of layering and blending techniques.

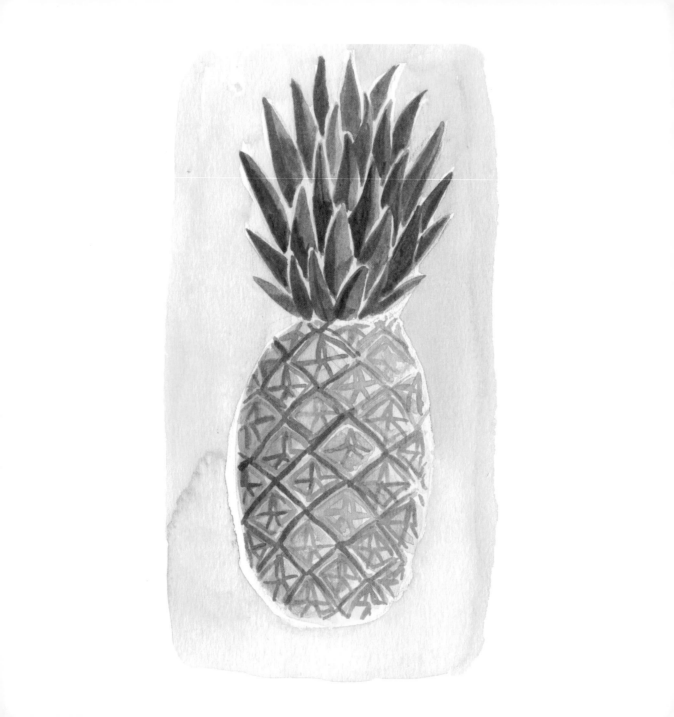

SIMPLE PINEAPPLE

In this painting, we will practice using multiple layers of color to create depth and detail.

YOU WILL NEED Large round brush · Medium round brush · Small round brush · Watercolor paper, about 8 x 10 inches · Pencil · Eraser
COLORS Cadmium yellow ◯ Yellow ocher ◯ Sap green ●
Burnt umber ● Cadmium red pale ●

Start by roughly sketching out the shape of the pineapple with your pencil. The pointed leaves should be almost as tall as the base of the pineapple. Create a watery mix of cadmium yellow and yellow ocher and paint the pineapple base using your large brush. When that is dry, paint the pineapple leaves in a watery wash of sap green with your medium brush. Let the whole thing dry completely.

Using a mixture of sap green and burnt umber, paint the individual leaves using your medium brush. Leave a very small space in between each leaf so they aren't quite touching each other. They will vary in tone naturally, as the amount of paint on your brush varies. Using a mixture of yellow ocher and sap green, paint a diagonal crisscross pattern on the pineapple base using your small brush.

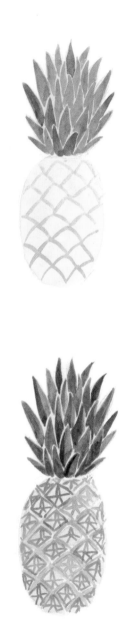

Give more depth to the individual pineapple leaves by adding additional layers of green paint with your medium brush. You can add slightly more burnt umber and slightly less water to make the paint mixture darker and more intense. Think about where the shadows would naturally be occurring on the leaves, and add darker tones there. Add detail to the base of the pineapple using a mixture of sap green and yellow ocher and a small brush. Once that is dry, add a watery glaze of yellow ocher to the sections of the pineapple using your medium brush. Once that is dry, further define the sections by painting a star shape in each using a darker sap green and yellow ocher mix and your small brush.

Add another layer of green paint to a few of the leaves using your medium brush, to add definition and variety in tone. When it's completely dry, rub off any pencil marks with an eraser and add a light background wash in a contrasting color. I chose a cadmium red pale wash to contrast with the green in the painting, but purple would work equally as well, as it would contrast with the yellow tones.

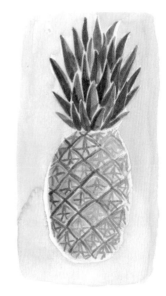

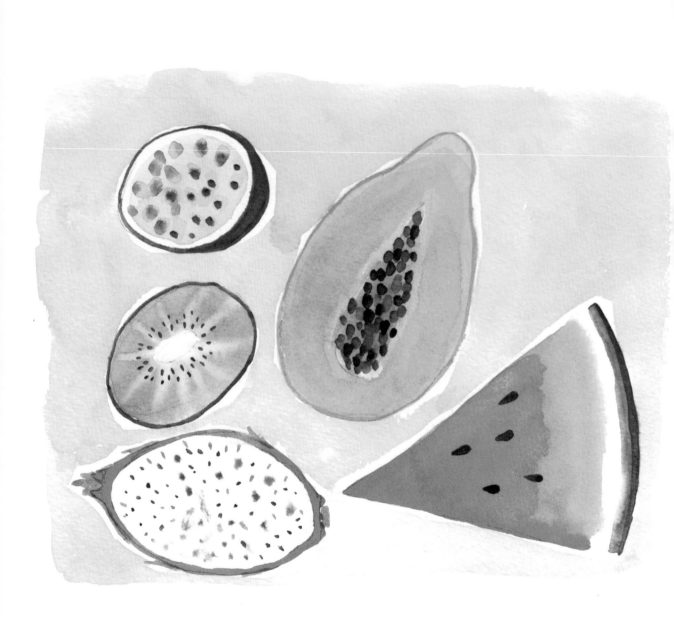

TROPICAL FRUIT

Sliced tropical fruit is a great subject for painting, as it provides a beautiful variety of textures and vibrant colors. In this painting, we use the wet-on-wet technique to create a soft, natural look to the fruit.

YOU WILL NEED Large round brush · Medium round brush · Small round brush · Watercolor paper, about 8 x 10 inches · Pencil · Eraser

COLORS Permanent rose ● Phthalo green ● Cadmium red pale ● Cadmium yellow ●
Sap green ● Sepia brown ● Burnt umber ● Lamp black ● Olive green ●

Start by sketching out a simple arrangement of sliced tropical fruit as lightly as possible with your pencil. I have included passion fruit, papaya, kiwifruit, dragon fruit, and watermelon.

Using a mixture of permanent rose and phthalo green and your small brush, paint the outside of the passion fruit. Using a large brush, paint inside the sketch of the papaya using just clean water. Whilst the area is still wet, paint a mixture of cadmium red pale and cadmium yellow over the papaya, leaving the center unpainted. Paint the kiwifruit with sap green using a large brush, leaving the center unpainted. Whilst still wet, dip a small brush in clean water and draw it from the center out toward the edge of the kiwifruit. Clean your brush in the water and

do the same again. Keep doing this, working all the way around, to give the effect of the subtle white lines of a kiwifruit. Paint the outline of the dragon fruit using a small brush and permanent rose. Using your large brush, paint inside the sketch of the watermelon slice using just clean water. Whilst it's still wet, add permanent rose using a large brush. Whilst it's still wet, you can keep adding more pigment to it and blending it. The watermelon slice should be darkest at the tip and lightest toward the rind. Because the paper was wet to start with, it should blend smoothly.

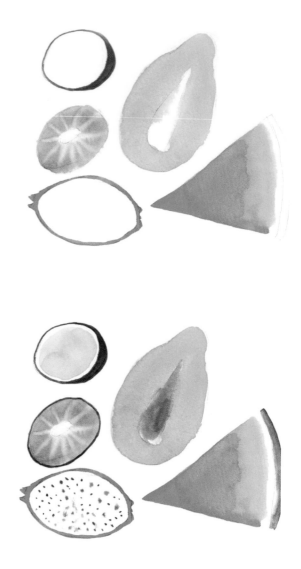

Once dry, use a mixture of cadmium yellow and a tiny bit of cadmium red pale to paint the center of the passion fruit with your large brush. Paint the center of the papaya using a watery wash of sepia brown and your medium brush. Using your small brush and burnt umber, paint the outside of the kiwifruit. Paint the inside of the dragon fruit using just clean water and your large brush. Whilst it is still wet, add seeds using lamp black and your small brush. In the areas where the paper is still wet, the seeds will spread and fade, giving the impression that they are embedded in the flesh of the fruit. Using your medium brush, paint the rind of the watermelon slice with olive green, leaving a white space in between the flesh of the watermelon and the rind.

Using your medium brush and a mixture of cadmium yellow and cadmium red pale, paint the seeds in the passion fruit. Whilst they are still wet, add centers to them with sepia brown. Still using your medium brush and sepia brown, add seeds to the center of the papaya. Vary the amount of paint on the brush to create seeds of different tones. Using your small brush and sepia brown, paint seeds on the kiwifruit, forming rings around the center. Again using your small brush and sepia brown, paint teardrop-shaped seeds in the watermelon slice.

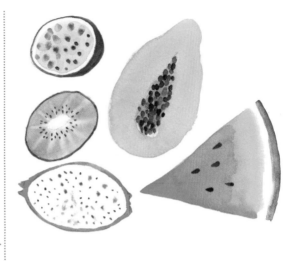

Using a mixture of cadmium yellow and cadmium red pale, add an outside skin to the papaya using your small brush. Using your large brush, add more of the orange mixture to the flesh of the papaya, giving it more depth and building up the color intensity. Using sap green and a small brush, add leaves to the edge of the dragon fruit. Using olive green and a small brush, add a darker line of green to the outside edge of the watermelon rind.

When everything is completely dry, rub away the excess pencil lines with an eraser and paint the background using a very light wash of cadmium red pale with a large brush. Work quickly to spread the paint over the paper before it dries. Don't worry about white gaps in between the fruit and the background. This keeps it looking fresh and vibrant.

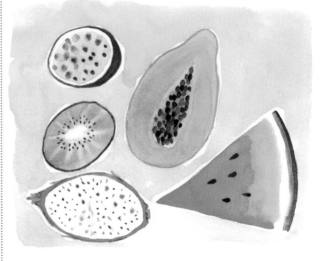

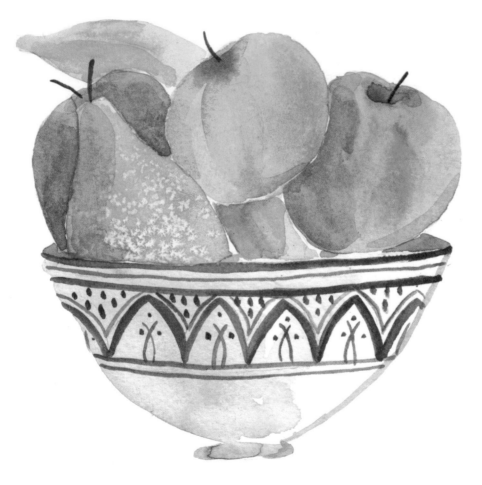

A BOWL OF FRUIT

A bowl of fruit is something of a watercolor cliché, but its advantage as a still life is that almost everybody has the materials to set it up at home. Work from my example here and then try setting up your own still life at home. Experiment with interesting combinations of fruit and bowls, contrasting the colors and experimenting with using a wide variety of fruit, or perhaps a bowl of all one type of fruit.

YOU WILL NEED Large round brush · Medium round brush · Small round brush
Watercolor paper, about 8 x 10 inches · Pencil · Table salt
COLORS Sap green ● Yellow ocher ● Cadmium yellow ● Cadmium red pale ●
Permanent carmine ● Sepia brown ● Prussian blue ●

Very lightly sketch out the fruit in the bowl with your pencil. I have included apples, bananas, a pear, and a peach. Start by painting the pear using a mixture of sap green and yellow ocher and a large brush. Add more yellow ocher to one side and more sap green to the other using the wet-on-wet technique. Whilst it's still wet, sprinkle it lightly with salt to give a speckled effect to the pear. Once it's completely dry, brush off the salt.

Using your medium brush, paint the peach using a mixture of cadmium red pale and cadmium yellow. Add more cadmium red pale to certain areas and allow the colors to mix on the paper whilst they are still wet.

Paint the apples using your large brush and sap green and permanent carmine, allowing the wet colors to touch each other and blend on the paper. Be careful not to mix them too much on the paper: you want defined areas of green and pink, not one gray apple. For the apple in the background, I added a little bit of sap green to permanent carmine first to tone it down a bit.

Once the apples are completely dry, paint the banana using your medium brush and cadmium yellow. Whilst the banana is still wet, add yellow ocher to the areas of the banana that would naturally be in shadow and add sap green to the tip of the banana.

Once the fruit is completely dry, add shadows to the fruit and the bowl using a very watery mix of sepia brown and your large brush. Apply the shadows loosely where they would naturally fall. Try to establish which direction the light is coming from in the picture, and remember to add shadows around the stem area on the peach and the apple on the right.

When that's completely dry, add decorative details to the bowl using Prussian blue and your small brush. Using sepia brown and your small brush, add stems to the pear, peach, and apples.

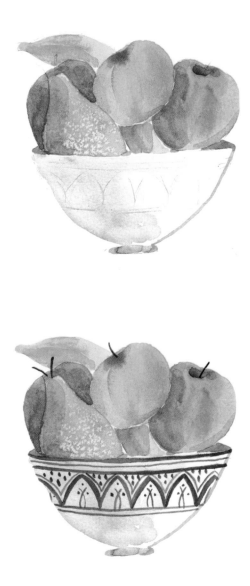

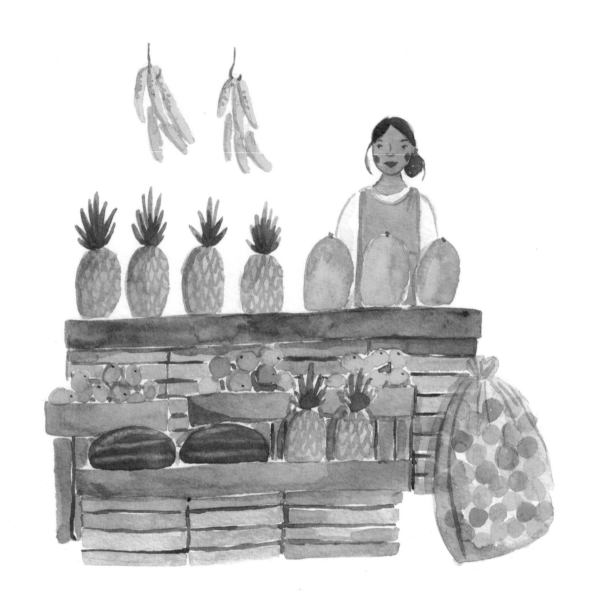

THE FRUIT MARKET

ADVANCED

This busy fruit stall, inspired by my travels in Mexico, is bursting with the bright, zesty colors of bananas, oranges, lemons, limes, papayas, pineapples, and watermelons. This may seem like a complicated painting, but we will build it up slowly step-by-step.

YOU WILL NEED Large round brush · Medium round brush · Small round brush
Watercolor paper, about 8 x 10 inches · Pencil

COLORS Cadmium yellow ⬤ Cadmium red pale ⬤ Yellow ocher ⬤ Sap green ⬤ Sepia brown ⬤
Olive green ⬤ Prussian blue ⬤ Cerulean blue ⬤ Burnt sienna ⬤ Permanent rose ⬤ Venetian red ⬤

Start by sketching the fruit stall as lightly as possible with your pencil. Using a mixture of cadmium yellow and cadmium red pale, paint the large papayas with your medium brush. Still using your medium brush, paint the pineapple bases with a mixture of yellow ocher and sap green, adding more green paint to the top of the pineapple bases. Paint the oranges using a mixture of cadmium red pale and cadmium yellow and a small brush. Vary the color of the oranges by adding more yellow or red to the paint mix. Allow the oranges to bleed into each other. Paint the limes with a mixture of cadmium yellow and sap green and your small brush. Paint the lemons with a mixture of cadmium yellow and sepia brown, again with your small brush. Paint the bananas using cadmium yellow with a touch

of sap green using your small brush. Paint the watermelons with olive green using your medium brush. Whilst the watermelons are still wet, dip your small brush in clean water and run it through the olive green in a horizontal line. This should lift away a thin stripe of green paint. Clean your small brush and do the same thing again until both watermelons have faint lines running across them. As you're doing this, be careful not to rest your hand in a section of the painting that is still wet. If need be, you can rotate the paper as you work.

Paint the trays that the fruit is sitting on using your medium brush: use Prussian blue for the top tray and a mixture of cerulean blue and sap green for the bottom trays.

Using a mixture of yellow ocher and sepia brown, paint the slats of the wooden boxes using your medium brush. Vary the intensity of the paint slightly for each slat. You will notice that the first one you paint will be darkest, and as you continue down they will get lighter as you run out of paint on your brush. Paint the woman's face using burnt sienna and yellow ocher. Paint the leaves of the pineapples using olive green and your small brush. Whilst the leaves are still wet, add more paint to the bases of the leaves to make them darker in color.

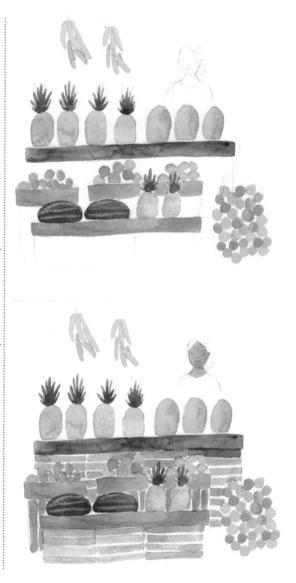

Using your small brush, paint sepia brown in between the slats of the boxes. Using your large brush, paint a very watery mixture of sepia brown over the bag of oranges. Once that is dry, add detail to the bag using sepia brown and your small brush. Paint the woman's tabard (the apron she wears) with permanent rose and your medium brush. You might notice that adding the dark shadow between the slats of the boxes makes the fruit appear less prominent and less defined; we will address this by adding more detail to the fruit, which will balance the image.

When everything is dry, use watered-down sepia brown and your small brush to add zigzag lines to the pineapples and shadow along the left-hand side. Again using your small brush and watered-down sepia brown, add shadow to the various fruits and small brown dots to the bananas, as well as hooks for them to hang on. Using sepia brown and your small brush, paint the woman's hair, eyebrows, and eyes. Add more water to the sepia brown and with your small brush paint her nose and outline her face, neck, and arms. Using Venetian red and your small brush, paint her lips and then add more water to paint her cheeks.

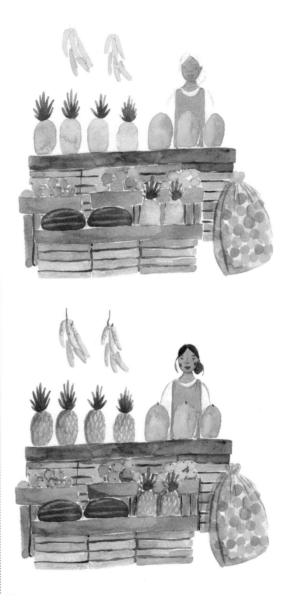

PAINTING PLANTS

I find plants, whether within the home or out-
doors, endlessly inspiring. Recreating their many shades and tones of green is a
great way to practice your color-mixing skills and to appreciate the endless variety in
nature. The transparent nature of watercolors is perfect for capturing the translucent
leaves of the plants and the way their colors subtly blend.

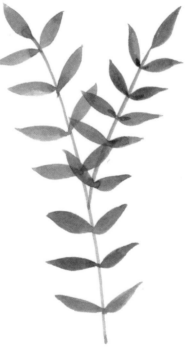
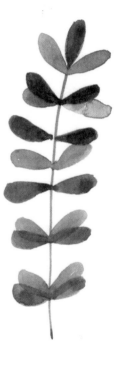

SIMPLE LEAVES

These three stems of leaves will put into practice some basic watercolor techniques: using two brush sizes for painting small and large areas, using the wet-on-wet technique, using the wet-on-dry technique to overlay layers of color, and using water to create different intensities of the same color.

YOU WILL NEED Medium round brush · Small round brush · Watercolor paper, about 8 x 10 inches

COLORS Viridian green ● Ultramarine blue ● Alizarin crimson ●

First, mix up a leaf color using viridian green, ultramarine blue, and a small amount of alizarin crimson. Using your small brush, paint a stem with three branches on each side. Once the stem is dry, paint circular leaves coming off the stem using a watery mixture of the paint and a medium brush. Paint the circles in a spiral motion, working inward toward the center. The wet mixture should allow the pigment to pool in different areas, and you should be able to see the stem through the leaves. Where the leaves touch they will blend into each other, and pigment will flow from one to another.

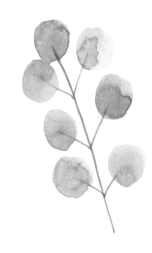

Using a small brush, paint a Y-shaped stem. Paint pointed leaves along one branch of the stem using the same brush. When those leaves are completely dry, paint leaves on the opposite side. Where the leaves overlap, they should create a darker color. If you painted the second set of leaves too soon, they will blend into each other.

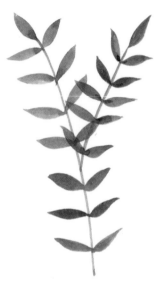

Using a small brush, paint a stem. Paint a set of rounded leaves using the same brush. When the leaves are dry, add more water to your paint mixture and paint a second set of leaves, which will appear paler than the first set.

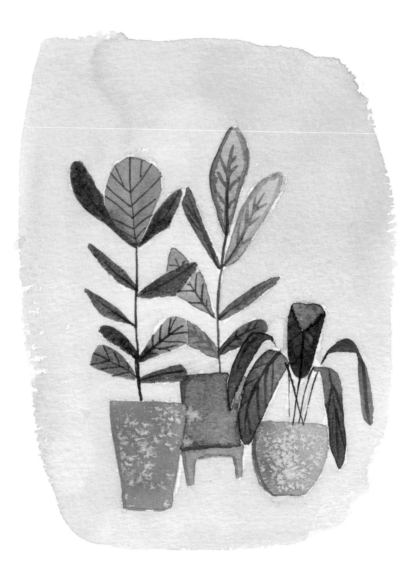

POTTED PLANTS

This simple arrangement of houseplants focuses on opposite colors, using green and red in a variety of tones and shades. Opposite colors are often found in nature—for example, in the red veins of green leaves or the green center of pink flowers. Taking plants out of a natural setting and bringing them indoors creates a contrast that works well in a painting.

YOU WILL NEED Large round brush · Medium round brush · Small round brush · Watercolor paper, about 8 x 10 inches · Pencil · Eraser · Table salt

COLORS Cadmium red pale ● Phthalo green ● Ultramarine blue ● Permanent carmine ● Sap green ● Venetian red ● Yellow ocher ● Burnt umber ●

First, lightly sketch out the plants and their pots with your pencil. I have sketched three overlapping potted plants, but you could keep it simple with just one to start. You want the sketch to be as light as possible, so you can only just see it. Mix a little bit of cadmium red pale with lots of water and fill in the background using your large brush, making sure to avoid the areas where the pots and leaves will be. If you find this difficult to do neatly, you can use masking fluid, as in the White Cosmos lesson (page 49). Let the background dry completely.

Whilst the background is drying, start mixing up some different shades of green. I like to use both blue-toned and yellow-toned greens in the same painting. I mixed phthalo green, ultramarine blue, and a touch of permanent carmine to make a turquoise-green color for the plant in the middle. I mixed some sap green with a little bit of ultramarine blue and Venetian red to paint the plant on the left. To paint the plant on the right, I added more Venetian red and more ultramarine blue to the sap green mixture. Experiment and play around until you find several different shades of green that you like. Before you start to paint the leaves, and once the background is dry, rub out the pencil lines with your eraser. The painted background will define the pots and plants, which means you don't need the pencil lines anymore. When you paint the leaves, apply the paint using your medium brush in light washes to some areas, and allow the paint to pool in dense areas of pigment in others where the leaves would naturally be in shadow or darker. This gives a sense of natural variation and the impression that light is catching the different angles of the leaves.

The next step is to paint the plant pots. I painted the pots with three different shades of red using a medium brush: cadmium red pale, Venetian red, and permanent carmine. Whilst they were still wet I sprinkled them with salt, which gives them an interesting textured effect. Brush the salt off once they're completely dry. I added a wooden stand to the pot in the middle using yellow ocher and burnt umber and a small brush.

Once the leaves are dry, add stems and veins using a darker shade of green and your small brush. I added more ultramarine blue and Venetian red to the sap green mixture to make a darker shade of green. I added veins to the middle plant using a mixture of permanent carmine and phthalo green.

To finish, using my small brush I added a bit of shadow to the side of the pots by painting a thin line of the same color used for each pot.

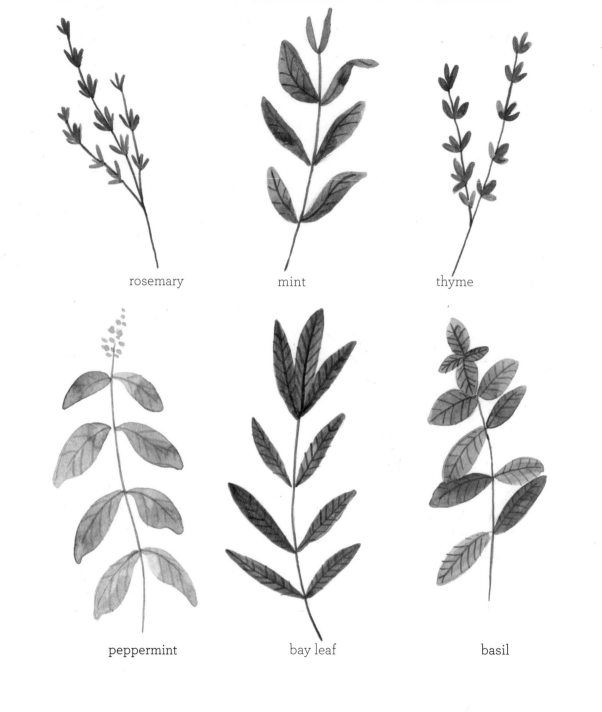

rosemary

mint

thyme

peppermint

bay leaf

basil

GARDEN HERBS

These simple paintings of herbs will help you develop your color-mixing skills and brush control.

YOU WILL NEED Medium round brush · Small round brush

Watercolor paper, about 8 x 10 inches · Pencil

COLORS Phthalo green ⬤ Venetian red ⬤ Olive green ⬤ Ultramarine blue ⬤ Sepia brown ⬤
Burnt umber ⬤ Permanent carmine ⬤ Sap green ⬤ Yellow ocher ⬤

Sketch out six simple herbs: rosemary, mint, thyme, peppermint, bay leaf, and basil. Just sketch one or two sprigs of each, not a whole plant.

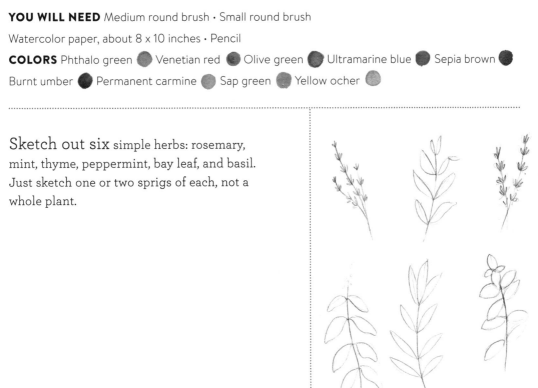

Using a mixture of phthalo green and Venetian red and a small brush, paint the leaves of the rosemary. Using a mixture of olive green, ultramarine blue, and sepia brown, paint the mint using your medium brush. Whilst the paint is still wet, add more pigment to certain areas to give a sense of depth and perspective. Using a mixture of olive green and burnt umber and your small brush, paint the leaves of the thyme. Using a mixture of phthalo green and permanent carmine and your medium brush, paint the leaves of the peppermint. As before, add more pigment whilst it is still wet, to add variety in tone and depth. Using a mixture of sap green and ultramarine blue, paint the bay leaves using your medium brush. Make sure you create a nice sharp point at the end of each leaf. Taking the excess paint off your brush with a tissue before starting can help you achieve a neat point. Using a mixture of olive green and yellow ocher and your medium brush, paint the basil. Vary the tone of each leaf, allowing each leaf to dry before starting the next so that they don't run into each other.

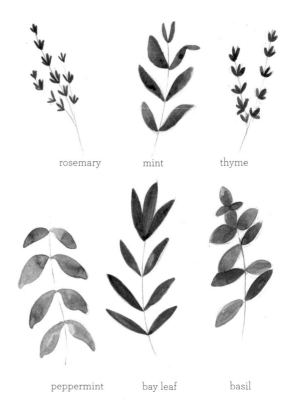

rosemary mint thyme

peppermint bay leaf basil

Once all the leaves are dry, use your small brush to paint the stems, veins, and flowers: Make a dark mixture of Venetian red and olive green and use it to paint the stems of the rosemary, bay, and basil. Paint the stems of the mint and thyme with sepia brown. Paint the stem of the peppermint with a mixture of permanent carmine and phthalo green, then add veins and flowers with the same color. Using a mixture of olive green and sepia brown, add veins to the peppermint, bay, and basil.

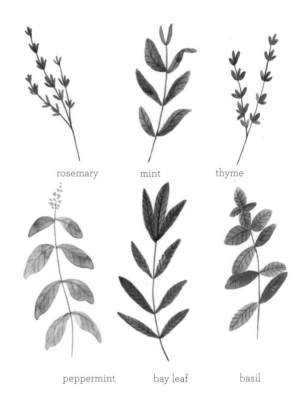

rosemary mint thyme

peppermint bay leaf basil

BOTANICAL WREATH

BEGINNER

Painting watercolor wreaths is one of my favorite things to do. The repetitive nature of painting the leaves and flowers is very meditative, and the way you build up the structure gradually is completely intuitive. These look great on stationery—particularly wedding stationery. They also look beautiful with a quote or phrase in the center.

YOU WILL NEED Small round brush · Watercolor paper, about 8 x 10 inches · Pencil

COLORS Sepia brown ● Burnt umber ● Sap green ● Phthalo green ●
Permanent carmine ● Cadmium red pale ●

First, very lightly sketch an oval with your pencil. Grip the pencil in the middle, not near the tip: this will allow you to create large sweeping strokes and smooth lines. Because of the delicate nature of this wreath, it will all be painted with a small brush. Paint sinuous branches using both sepia brown and burnt umber, following the direction of the pencil guidelines and alternating between the two shades of brown. The aim is for the branches to feel natural and organic: some can connect and touch each other, and others can be floating on their own.

Once the branches are dry, use your small brush and a mixture of phthalo green and permanent carmine to paint oak leaves growing out from the branches. Make sure there are leaves pointing in toward the middle of the wreath as well as out toward the edge of the paper. With a mixture of sap green and burnt umber, paint longer, pointed leaves coming off the branches.

Using cadmium red pale, paint simple flowers with five petals. Whilst the flowers are still wet, add a dot of more intense cadmium red pale to the centers. On a couple of the branches, paint simple birds using a light mix of cadmium red pale for the body and a darker shade for the wing. Using permanent carmine, paint berries at the end of the branches: place the tip of your brush on the paper and give it a slight wiggle to create a tiny circle.

Painting a wreath is all about creating a
sense of balance. At this point you need to step
back and look at the wreath to decide where it
needs more detail. Using a mixture of phthalo
green and permanent carmine, add long, pointed
leaves to the wreath, filling in gaps. Once these
are dry, add more details using sepia brown: for
example, add veins to the center of the leaves or
beaks and legs to the birds.

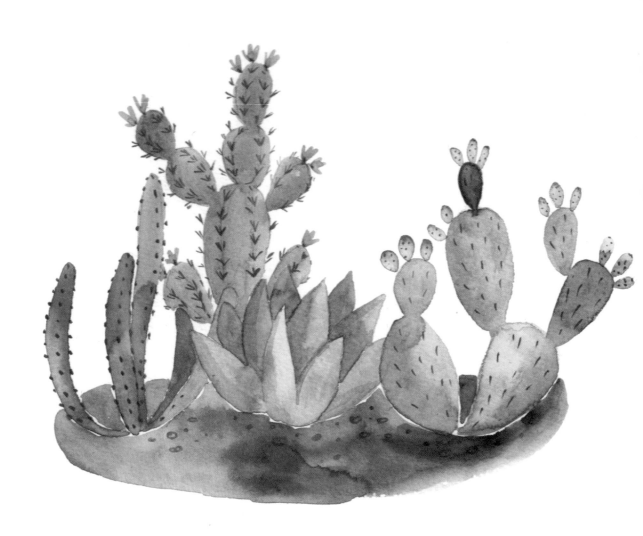

CACTI GARDEN

This piece is inspired by the cacti I saw on vacation in Lanzarote (one of the Canary Islands). Traveling can be a great source of inspiration. I drew these in my sketchbook at the time and then later used them as inspiration for a painting. This painting will develop your mixing skills as you create various shades of green, and it will help you practice using the watercolor effect of allowing the watercolor to pool and blend.

YOU WILL NEED Large round brush · Medium round brush · Small round brush
Watercolor paper, about 8 x 10 inches · Pencil

COLORS Olive green ● Ultramarine blue ● Phthalo green ● Permanent carmine ●
Sap green ● Venetian red ● Cadmium red pale ● Sepia brown ●

Start by sketching out a simple arrangement of cacti with your pencil. I have sketched four varieties of cacti, which are all overlapping slightly.

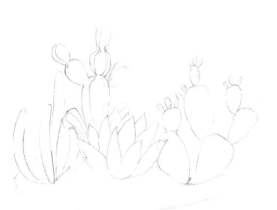

Using a mixture of olive green and ultramarine blue, paint the cactus on the left using a medium brush. If you are right-handed, you should always work from left to right when you're painting a picture to avoid smudging it. If you are left-handed, work from the right to left. Deliberately encourage as much variation in tone as possible when painting the cactus. Paint one section

of the cactus dark green, then dip your brush into clean water and use that to spread the pigment down the rest of the section, creating a paler area. Paint each section of the cactus one at a time and let it dry before starting the next so that each section remains distinct.

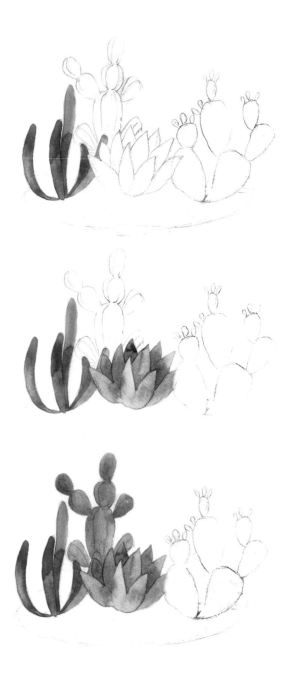

Paint the next cactus using a mixture of phthalo green and permanent carmine and your medium brush. Add a small amount of the permanent carmine to the green until you get the right shade. Again try to encourage as much variation in tone as possible, adding water to sections of the painting and then blending it. In some instances, I have painted several leaves at once, allowing the colors to pool and blend between them; in other sections I've allowed the leaves to dry first, making them more distinct and separate. As the leaves go further back, add more and more pigment to make them darker and give a sense of depth.

For the next cactus, use a mixture of sap green and ultramarine blue and your medium brush. If the previous cactus isn't dry yet, you can rotate your piece of paper to avoid smudging it. Add more ultramarine blue to certain areas to indicate shadow and perspective.

For the final cactus, use a mixture of olive green and ultramarine blue and your medium brush. Allow the paint to flow from one section of the cactus to another.

The next step is to add detail to the cacti. Using a mixture of olive green and Venetian red and your small brush, add spines to three of the cacti. Think about how the spines would follow the natural shape of the cacti. Using a mixture of cadmium red pale and permanent carmine and your small brush, add flowers to the cactus in the background. Using a mixture of permanent carmine and a very small amount of phthalo green, paint prickly pears on the cactus on the right. When they are dry, add prickles to them using your small brush and the mixture of Venetian red and olive green.

Using your large brush and sepia brown, paint the ground under the cacti. You can create more variety of tone by adding paint directly from the tube or pan to the wet paper. When that is dry, use your small brush and sepia brown to paint a few small pebbles.

OVERGROWN GARDEN

This project deals with the subject of a landscape in a more stylized manner, using a limited color palette. We're not aiming for realism here; instead, we want to evoke a mood. This painting is created with only four colors from your paint set, using scale to create perspective and a sense of depth. We will be using masking fluid and layering washes of paint to add depth and details within the painting.

YOU WILL NEED Large round brush · Medium round brush · Small round brush · Small old brush for applying masking fluid · Watercolor paper, about 8 x 10 inches · Masking fluid Brown water-soluble pencil

COLORS Olive green ● Yellow ocher ● Sepia brown ● Permanent carmine ●

Using masking fluid and a small old brush, paint simple daisies over the lower half of the paper: make some of them fully open, facing forward, and some only partly open, facing the sky, and some as closed buds. When the masking fluid is completely dry, sketch in a garden shed using a brown water-soluble pencil.

Paint the background using your large brush and a watery wash of olive green and yellow ocher, being careful to avoid painting over the shed. Add more olive green as you work down the page so that the lower half of the page is deeper in color than the top. Leave some white spaces at the edge of the paper: it's fine for the background to have raw edges and texture.

When that is completely dry, paint the garden shed using a watery mixture of sepia brown and your medium brush. Paint one side at a time, allowing them to dry in between, so a natural edge between the layers of watercolor forms. Make the roof of the shed slightly darker by adding more pigment. Using a mixture of olive green and yellow ocher, paint bushes behind the shed and the tops of trees using your large brush: move the brush in a circular motion to make cloudlike shapes. Vary the tone by adding more water or pigment as you go.

Using your small brush, add detail to the shed by painting broad stripes of sepia brown to indicate planks of wood. Leave small gaps in between the stripes of sepia brown so the lighter background wash shows. Once that is completely dry, add stems to the flowers and additional wild grasses: use a mixture of olive green and sepia brown and your small brush to paint lots of thin vertical lines. Make the lines at the front the longest and darkest, and the lines at the back shorter and lighter to create a sense of depth.

Once the lines are dry, add leaves to them using your small brush and the mixture of olive green and sepia brown. Use a more watery mixture to add leaves to the stems in the background. Make the leaves in the foreground darker and larger. Using your small brush, paint trunks and branches on the trees using sepia brown.

Once all of that is completely dry, very carefully remove the masking fluid. A good way to do this is to rub it off with an eraser. You can also peel it off with your fingers. Once the masking fluid is removed, it should leave clean white paper underneath. Using your small brush, add yellow ocher to the centers of the open daisies. Again using your small brush, add a light wash of permanent carmine to the sky-facing closed daisies. (See final painting on page 104).

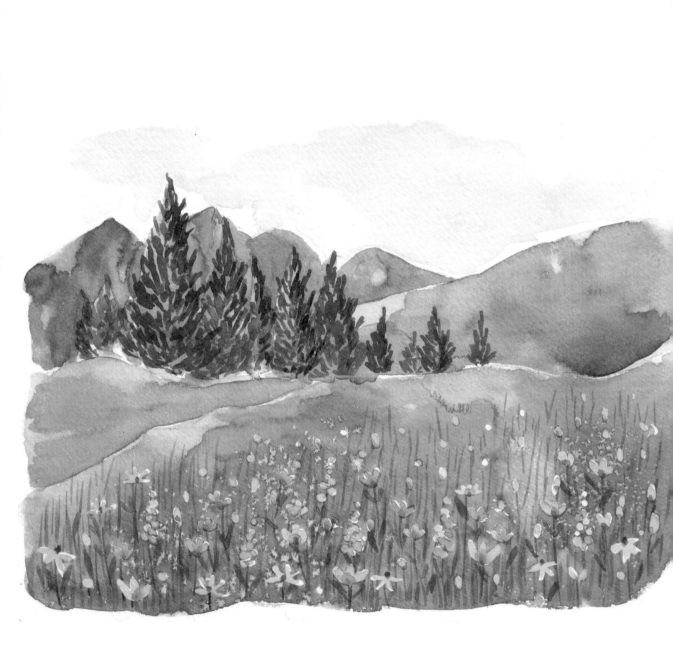

COLORADO WILDFLOWERS

ADVANCED

This piece uses broad, loose brushstrokes to capture the atmosphere of this serene natural scene. It also uses salt and masking fluid to create the busy field of wildflowers. The overwhelming greenness of nature is balanced by the pink sky, wildflowers, and purple mountains.

YOU WILL NEED Large round brush · Medium round brush · Small round brush
Small old brush for applying masking fluid · Watercolor paper, about 8 x 10 inches · Masking fluid
Brown water-soluble pencil · Eraser · Table salt
COLORS Olive green ● Venetian red ● Permanent carmine ● Phthalo green ●
Sepia brown ● Cadmium red pale ● Cadmium yellow ●

Using a brown water-soluble pencil, sketch out trees, mountains, and hills. Using a small old brush, paint wildflowers using masking fluid. Make the wildflowers larger toward the bottom of the page and smaller further up the page to give a sense of perspective.

When the masking fluid is completely dry, use your large brush and a mixture of olive green and a tiny bit of Venetian red to paint the lower half of the paper. Whilst the paint is still wet, sprinkle some salt over it to add more texture. Once it's completely dry, brush off the salt.

Use a mixture of permanent carmine and phthalo green to create a muted purple color, and paint the mountains using your medium brush. Add extra water and extra pigment to the wet paint to create as much variety in tone as possible. Paint the mountains roughly, without worrying about making them too perfect.

Using a mixture of olive green and sepia brown and a small brush, paint the fir trees and hills in the distance. Again, add extra pigment and water whilst painting them to encourage lots of variety in tone, and don't worry about painting too neatly. You want your brushstrokes to be loose and expressive.

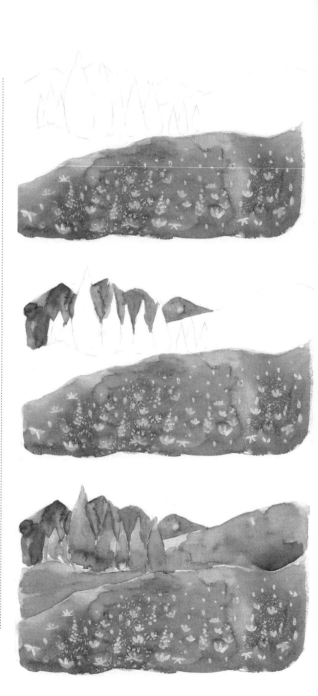

Using your small brush and a darker mixture of olive green and sepia brown, add detail to the fir trees. Create diagonal brushstrokes going upward to give the impression of branches.

Once that is dry, use the darker mixture of olive green and sepia brown and your small brush to add grass to the wildflower field. Paint stems and leaves on the wildflowers. When everything is completely dry, carefully remove the masking fluid using an eraser.

Using your small brush and a watery mixture of cadmium red pale, start to fill in some of the flowers. Whilst they are still wet, add a dot of stronger cadmium red pale to the base to create color variation and shading. Fill in some of the other flowers using a watered-down mixture of permanent carmine. Paint the last of the flowers using cadmium yellow and add centers using Venetian red.

Using a very watery mixture of cadmium red pale and your large brush, paint the sky loosely, allowing small areas of white paper to remain between the sky and the mountains. (See final painting on page 108.)

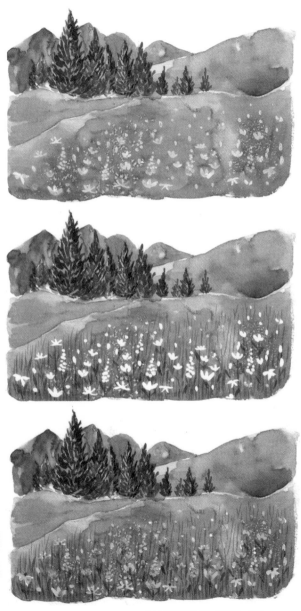

PAINTING
OBJECTS

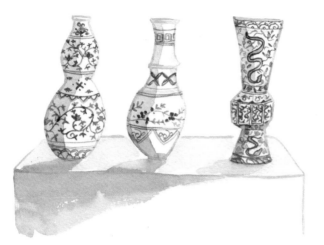

These exercises show you how simple objects

found around the house can make great subjects for a painting. Even the most mundane things, like a stack of cereal bowls, can provide inspiration for painting. By learning to see the world as an artist, you start to notice beauty in the everyday, and appreciate the color and form of ordinary objects.

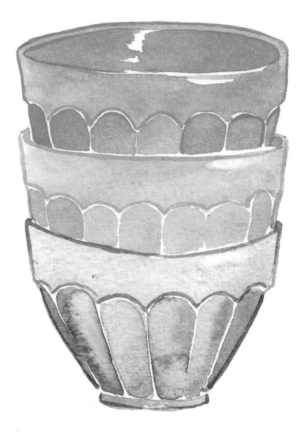

STACKED BOWLS

BEGINNER

This painting shows how everyday items can be great subjects for a painting, and, it will help you develop your observational drawing skills. This painting will help you practice creating perspective and painting different surfaces and textures.

YOU WILL NEED Medium round brush · Small round brush

Watercolor paper, about 8 x 10 inches · Pencil

COLORS Cadmium red pale ⬤ Ultramarine blue ⬤

Sketch three stacked bowls lightly with your pencil.

Paint the rim of the top bowl using cadmium red pale and your medium brush, leaving an unpainted spot on the right side to show the reflection of light on the rim. Paint the next bowl using a more-watered-down mixture of cadmium red pale, again leaving an unpainted spot for the glare. Paint the last bowl using a watery mixture of ultramarine blue, again leaving an unpainted spot. Let it all dry completely.

Using your medium brush, paint all the individual sections of the top bowl using cadmium red pale, leaving a small amount of white space between each one. On the inside of the top bowl, leave a small space unpainted, opposite the spot on the outer rim, to show the reflection of light. Paint the individual sections of the next bowl in the same way, using a more watery mixture of cadmium red pale. Paint the final bowl in the same way with ultramarine blue. Vary the intensity of each section and allow the color to pool in different areas to add interest.

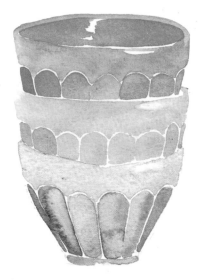

Once the bowls are dry, outline the top bowl using your small brush and cadmium red pale. Outline the middle bowl in the same way with a lighter mixture of cadmium red pale. Outline the bottom bowl using ultramarine blue.

ANTIQUE VASES

I always find walking around a museum with a sketchbook or visiting a beautiful exhibition really inspiring. There is something about seeing great works of art close up, seeing the texture of the paint and the individual brushstrokes, that makes me want to pick up a paintbrush as soon as I get home. Statues and objects in museums are a great tool for practicing sketching and painting. In this project, we will be painting three beautiful antique vases. We will be using shadow to give the vases a three-dimensional form and adding decorative detail with a simple color palette.

YOU WILL NEED Large round brush · Medium round brush · Small round brush
Watercolor paper, about 8 x 10 inches · Pencil
COLORS Sepia brown ● Ultramarine blue ● Prussian blue ●

First, sketch out the three vases and the plinth lightly with your pencil. When sketching the vases, make sure that they are each symmetrical and that the lines of the plinth are straight.

Using a watery mixture of sepia brown and your medium brush, add the shadow to the left-hand side of the vases, following their shape with the brush. Paint shadows leading from the bottom of the vases to the edge of the plinth and paint a diagonal area of shadow on the front of the plinth. Using your small brush and sepia brown, paint the outlines of the vases and the plinth.

Using a mixture of ultramarine blue and Prussian blue and your small brush, paint the details on the vases. The key to this is to keep the designs delicate and to stop them from all running into each other. Vary the amount of water in the blue paint mix to create different tones when painting the details.

Once the details are dry, use sepia brown and your small brush to outline the left-hand side of the vases. Using a very watery mixture of sepia brown and your large brush, paint the top of the plinth.

FLORAL ARM CHAIR

INTERMEDIATE

This project shows that simple objects around the house can make great subjects for a painting, particularly if they involve strong colors or a decorative print. This painting uses negative space to create the shape of a chair and has a simple, bold color palette.

YOU WILL NEED Large round brush · Medium round brush · Small round brush
Watercolor paper, about 8 x 10 inches · Pencil · Eraser
COLORS Permanent carmine ● Sepia brown ● Cadmium red pale ●
Yellow ocher ● Olive green ●

Sketch the chair lightly with your pencil.
I find it easiest to sketch a chair at a diagonal
angle. Sketching out a diamond shape connecting
the bottom of all the chair legs should help you
get them in proportion.

Paint the background using permanent carmine and your large brush, being careful not to paint over the pencil lines.

When the background is completely dry, use your small brush and sepia brown to paint the wooden legs and detailing on the chair. Using your medium brush and a more watery mix of sepia brown, add shadows to the chair. Think about what direction the light would be coming from and where the shadows would form. If the shadows are too dark at first, you can always blot them with a tissue.

When that is completely dry, rub out any remaining pencil marks with an eraser and then start to fill in the floral pattern. Using a small brush, paint simple flowers using a mix of cadmium red pale and permanent carmine. When the flowers are dry, add leaves using your small brush and a mixture of yellow ocher and olive green.

When the leaves are completely dry, add centers to the flowers using your small brush and sepia brown. Using a more watery mixture of sepia brown, use your small brush to add more details to the chair, such as tufting and an outline of the cushions.

MINT BROGUES

Shoes make a great subject to paint, whether they are scruffy sneakers, glamorous heels, or lace-up brogues. Shoes always say something about the person that owns them, and in some ways to paint one's shoes is to paint a kind of self-portrait. This painting uses the wet-on-wet technique to add interest, and it layers color washes to add depth.

YOU WILL NEED Medium round brush · Small round brush · Watercolor paper, about 8 x 10 inches
Pencil

COLORS Yellow ocher ● Burnt umber ● Phthalo green ●
Permanent carmine ● Sepia brown ●

Sketch the shoes lightly with your pencil.
The easiest angle to sketch a pair of brogues is
from directly above. Whatever shoes you choose,
experiment to find the best angle; for example,
high heels are better drawn from the side.

Using your small brush and a mixture of yellow ocher and burnt umber, paint the laces and the sides of the insoles.

Using a mixture of phthalo green and permanent carmine and your medium brush, paint the upper portion of the shoes. Paint each section of the brogues separately, allowing each to dry before starting the next one. Make some sections of the shoe lighter or darker than others and allow the pigment to pool randomly in certain areas.

Using your small brush and a more intense mixture of phthalo green and permanent carmine, add detailing to the shoes, such as stitching and perforations.

Using a pale mixture of yellow ocher and burnt umber and your medium brush, paint the inside of the shoes. When that is dry, add stitching to the insoles using your small brush and burnt umber.

Using your medium brush, add a watery mixture of phthalo green and permanent carmine to the left-hand side of the shoes to add shadows and depth. Using your medium brush and sepia brown, add shadows under the shoes on the left-hand side to add another layer of depth to the image.

PAINTING FOOD

It is natural to want to have a go at painting the
delicious food that appears in front of you: the difficulty is that often our favorite
foods are beige or brown. I have chosen food that is naturally colorful, like sushi,
a cupcake, cheesecake, and ice pops, as they are a variety of colors, shapes, and
textures. It is a great skill to be able to paint food that not only looks like what it is
supposed to be, but also looks delicious and tempting.

CUPCAKE WITH CHERRY

This painting uses negative space to create the white frosting on top of the cupcake. You can make the background and cupcake wrapper any color you like. This simple painting allows you to practice using shadows, depth, and perspective.

YOU WILL NEED Large round brush · Medium round brush · Small round brush

Watercolor paper, about 8 x 10 inches · Pencil · Eraser

COLORS Olive green ● Yellow ocher ● Sepia brown ● Permanent carmine ●

Phthalo green ● Cadmium red pale ●

Lightly sketch a cupcake with frosting and a cherry on top with your pencil.

Fill in the background around the cupcake using a mixture of olive green and yellow ocher and your large brush. When that is dry, paint the shadows on the frosting using a watery mix of sepia brown and your medium brush. Make sure to leave plenty of areas of white unpainted paper.

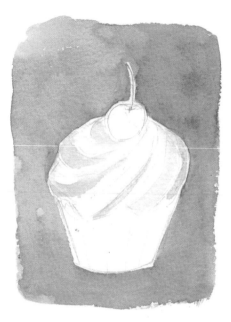

When that is dry, paint the cherry on top using a mixture of permanent carmine and phthalo green. Make one side lighter than the other as if it is catching the light. Paint the cupcake wrapper using a watery mix of cadmium red pale and your medium brush. Rub out any remaining pencil lines with an eraser.

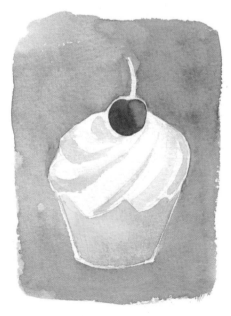

Using your small brush, paint sprinkles on the frosting. I have used cadmium red pale, permanent carmine, the olive green and yellow ocher mixture from the background, and a mixture of phthalo green and a tiny bit of permanent carmine. Be careful to vary the angle of each sprinkle so they look natural. Using your small brush and sepia brown, paint the stem of the cherry. Using your small brush and cadmium red pale, add shadows to the cupcake wrapper.

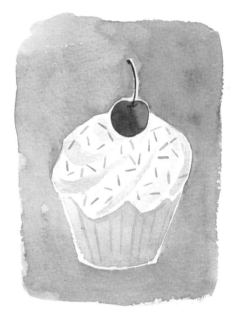

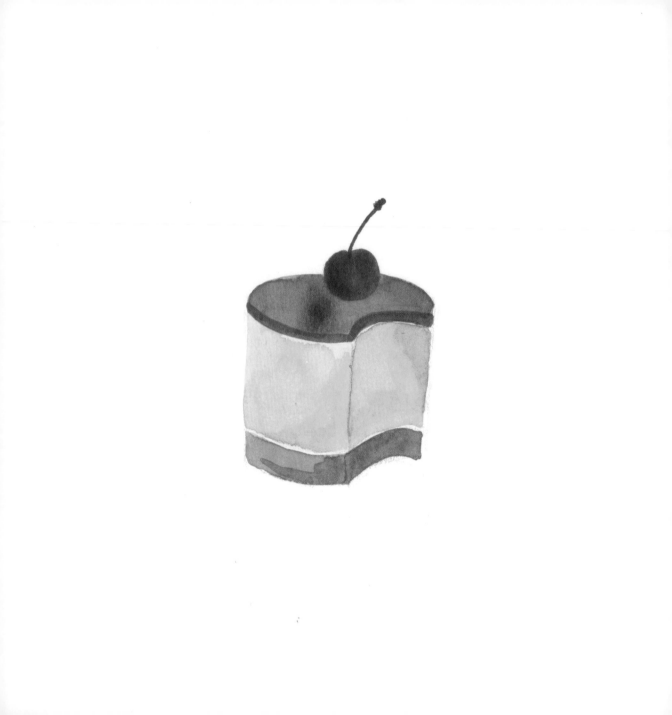

CHERRY CHEESECAKE

Allowing watery washes of color to pool on the paper creates subtle variations in tone that are great for capturing glossy surfaces. In this painting, the glossy surface of the cherry and the cherry glaze is created by allowing a deep red wash of watercolor to pool. This technique takes a little bit of patience, as it can take a long time for the paint to dry, but it is worth it for the effect.

YOU WILL NEED Large round brush · Medium round brush · Small round brush
Watercolor paper, about 8 x 10 inches · Pencil
COLORS Alizarin crimson ● Viridian green ● Cadmium red pale ●
Yellow ocher ● Burnt umber ●

Start by sketching out the cheesecake with your pencil. Sketch a cylinder shape first, then remove a curved section where a spoonful has been eaten, and add the cherry on top. Using your medium brush, mix alizarin crimson with a tiny bit of viridian green. The more green you add, the darker the crimson will become. Paint the cherry by applying lots of paint to the paper, letting the pigment naturally pool. It should look very glossy and shiny and take a long time to dry. Use your small brush to paint the cherry stalk.

Whilst the cherry is drying, mix equal parts cadmium red pale and alizarin crimson with lots of water to create a pale pink color. Paint the first section of the cheesecake using your large brush.

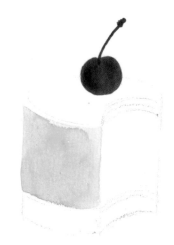

Once the cherry is completely dry, paint the cherry glaze using your medium brush and mixture of alizarin crimson and viridian green. Use the same technique as before, allowing the wet paint to pool in certain areas to create a glossy effect.

Whilst the cherry glaze is drying, mix yellow ocher with burnt umber and paint the cookie base using your medium brush. When the cherry glaze and cookie base are both dry, paint the final section of the cheesecake using the pink tone. Add definition to the cherry glaze by painting another layer of the alizarin crimson mixture along the edge with your small brush.

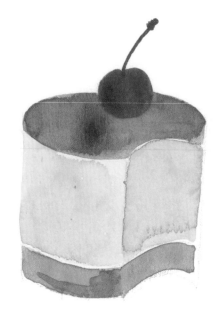

Add more depth to the cheesecake where a spoonful has been scooped out by painting another layer of watered-down pink color over the cookie base and cheesecake with your medium brush.

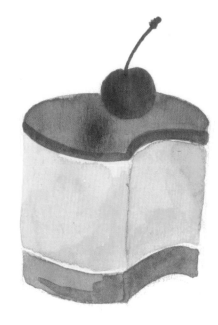

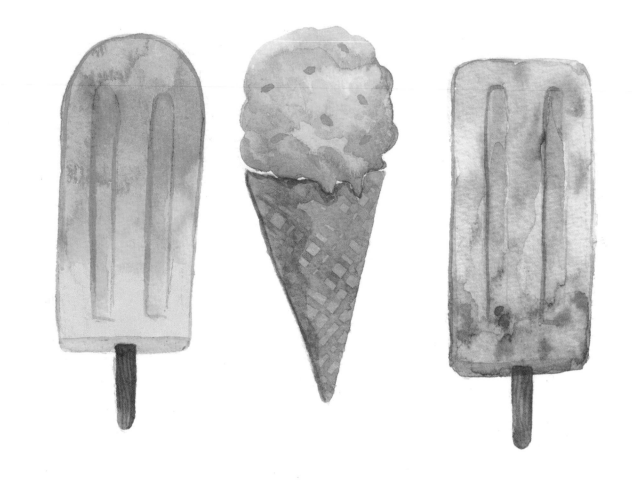

FROZEN TREATS

Frozen desserts like ice cream and ice pops are a great subject for a painting due to their bright colors. The blending of flavors in ice pops is perfectly captured by the use of wet-on-wet technique. We will also use color layering to add texture and depth.

YOU WILL NEED Large round brush · Medium round brush · Small round brush

Watercolor paper, about 8 x 10 inches · Pencil

COLORS Cadmium red pale Cadmium yellow Permanent carmine Ultramarine blue

Burnt umber Yellow ocher

Sketch the ice pops and ice cream cone lightly with your pencil.

Using your medium brush, paint the top of the first ice pop using cadmium red pale, paint the middle section using a mixture of cadmium red pale and cadmium yellow, and paint the bottom section with cadmium yellow. Paint these sections one after another whilst the paint is still wet so that the colors blend. Paint the ice cream using a mixture of cadmium red pale and permanent carmine and your medium brush. Add more water directly to the painting of the ice cream whilst it is still wet, to create a variety of tones and effects. Paint the second ice pop using a mix of ultramarine blue and permanent carmine and your medium brush. Paint a light layer all over the ice pop first. Add slightly more permanent carmine to the paint mix and then add spots of this color to the wet painting to give the effect of berries frozen within the ice pop. When that is dry, add slightly more ultramarine blue to the paint mix and paint two broad stripes down the middle of the ice pop using your medium brush.

Paint the sticks of the ice pops using a mixture of burnt umber and yellow ocher and your medium brush. Add more yellow ocher and water to the mixture and paint the ice cream cone using your large brush.

Using your small brush, outline the ice pop on the left in cadmium red pale, including outlines of two vertical indentations in the middle of the ice pop. Outline the ice pop on the right using a mixture of ultramarine blue and permanent carmine. With your small brush, paint a crisscross pattern on the cone using a mixture of yellow ocher and burnt umber. With your small brush and burnt umber, add wood texture to the sticks.

When the cone is dry, use a watery mixture of burnt umber and your medium brush to add shadow on one side. Using your medium brush and a watery mixture of cadmium red pale and permanent carmine, add shadows and texture to the ice cream. When that is dry, paint individual strawberry pieces using your small brush and a more intense mixture of cadmium red pale and permanent carmine.

SUSHI

Sushi is an ideal subject for a painting, as it has such a clear aesthetic, with strong colors, the bold contrast of black and white, and simple geometric shapes. This painting will develop your skill in painting small details.

YOU WILL NEED Large round brush · Medium round brush · Small round brush · Watercolor paper, about 8 x 10 inches · Pencil

COLORS Sepia brown ⬤ Lamp black ⬤ Olive green ⬤ Cadmium red pale ⬤ Sap green ⬤ Permanent carmine ⬤ Cadmium yellow ⬤ Yellow ocher ⬤

Sketch out the five pieces of sushi using your pencil. These are composed of simple cylindrical and cuboid shapes.

Using your small brush and a watery mixture of sepia brown, outline the individual grains of rice. Don't wait for each grain of rice to dry before starting the next: paint them one after another, allowing the edges of the rice to blend as they touch. Allow that to dry completely before moving on.

Using your medium brush and a mixture of lamp black and olive green, paint the nori on the outside of two of the pieces of sushi. Add more pigment to the left-hand side of the sushi to indicate depth and perspective. Using your small brush and the black-green mixture, add nori on the inside of two other pieces of sushi.

Use your small brush and a watery mixture of cadmium red pale to paint the salmon inside the top-left piece of sushi. Add more water and paint salmon filling in half of the center of the bottom-left piece of sushi and in a third of the top-right piece of sushi. Use your small brush and sap green to paint the avocado inside the bottom-center piece of sushi, filling the other half of the bottom-left piece of sushi, and filling in a third of the top-right piece of sushi. Using your small brush and a watery mixture of permanent carmine, outline the edge of the crab stick in the top-right piece of sushi. Using a mixture of cadmium yellow and yellow ocher and a medium brush, paint the slice of egg on top of the rectangular piece of sushi.

Using a mixture of cadmium red pale and cadmium yellow and your medium brush, paint the outside of one of the pieces of sushi to show a coating of roe. Whilst it is still wet, add more dots of the orange color. Using a small brush and lamp black, add dots for black sesame seeds to the outside of one of the pieces of sushi, and add a thin black band of nori around the yellow egg and rice on the rectangular piece of sushi.

Using your small brush and a darker version of the red-yellow mixture, add more-defined orange circles to the roe on the outside of the sushi. Using your large brush, paint a background of permanent carmine, leaving a bit of white space between the sushi and the background. Add more permanent carmine to the paint mix as you work down the page.

PAINTING
PEOPLE

People are the most difficult thing to learn how

to paint, in my opinion. From the moment we open our eyes for the first time,
our biological instinct is to recognize the human face. This means that if there is
something slightly wrong with a portrait, it is usually very obvious to the viewer—
although unfortunately it's not always immediately obvious when you're painting it. If
you paint an apple or a flower slightly wonky, nobody is likely to know the difference.
If you paint a person's face slightly wonky, it will be instantly apparent. Unfortunately,
there is no quick route to learning how to draw and paint people. It can take years of
observation and practice to master this skill. The best way to learn to draw people
is to draw from life, and I would recommend taking life-drawing classes if possible;
if not, ask a friend or family member to sit for you whilst you sketch. The most
important skill when drawing people from life is taking the time to look and not just
drawing what you think is there. When painting from observation, you should spend
as much time looking at the subject as painting it. It is important when learning to
draw people to draw from life as much as possible, and not just rely on working from
photos. And when drawing from life, don't worry too much about creating a likeness
at the beginning: try to capture the person's proportions and gestures first.

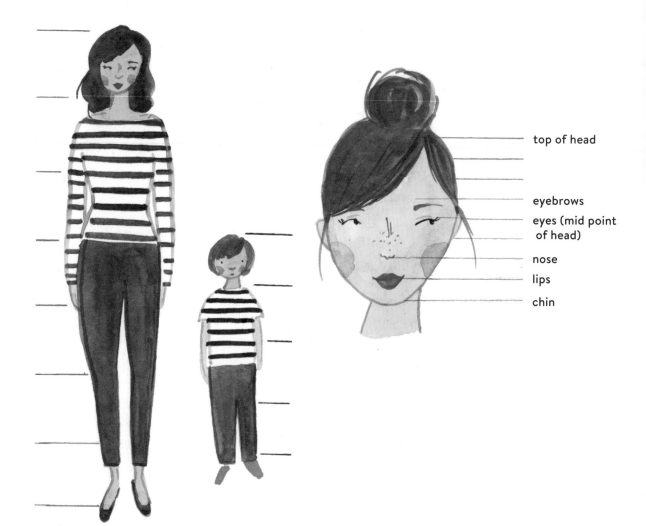

top of head

eyebrows

eyes (mid point
of head)

nose

lips

chin

These drawings indicate the rough proportions of adults and children and the face, although you may not want to stick to these too rigidly as you develop your own style. Even if you are working in a highly stylized way, it is important to understand basic human anatomy first. Generally, the proportions of an adult work out that their height is equal to seven heads. Young children have much larger heads in proportion to their body. The young child in this example is four heads tall, but this will vary depending on the child's age. The younger the child, the bigger their head in proportion to their body. In stylized illustration, you will often see these proportions disregarded; for example, in fashion illustration, people may be much taller, perhaps eight or nine heads, and in children's book illustration, people may be much shorter, appearing round and friendly.

The eyes are roughly on the midline of the head. The nose is halfway between the eyes and the chin, and the lips are halfway between the nose and the chin. The eyebrows are a quarter of the way up from the eyes to the top of the head, and the ears are level with the eyes. I don't suggest following these guidelines too slavishly, but they are useful to reference when you are practicing drawing faces.

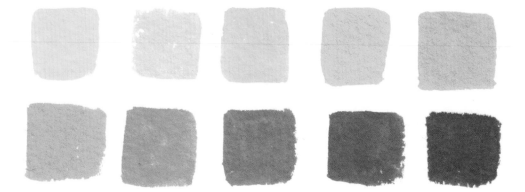

SKIN TONES

Many artists have a highly complex way of capturing human skin tones, including endless variations in tone and hue. Some artists pick out undertones of purple, yellow, and even green, exploring light and shadow on the face. Due to my illustrative style, I have a simple method for painting skin tones: I use Chinese white as a base and then add varying amounts of burnt sienna, yellow ocher, and burnt umber to create a variety of skin tones. The Chinese white stops the mixture from being too watery even when it is very pale, and it makes the resulting application of paint more even in tone. I always start by adding burnt sienna to the Chinese white base, as it is the warmest of the earth colors and will work in most skin tones.

YOU WILL NEED Medium round brush · Watercolor paper, about 8 x 10 inches
COLORS Burnt sienna ● Chinese white ○ Yellow ocher ● Burnt umber ●

Start by mixing a small amount of burnt sienna with Chinese white using your medium brush. Paint a swatch. Add yellow ocher to the mixture and paint a swatch next to the first swatch. Add more yellow ocher to the mixture and paint another swatch. Add more burnt sienna to the mixture and paint another swatch. Keep adding both burnt sienna and yellow ocher at the same time and paint another two swatches, getting progressively deeper in color. Add a tiny bit of burnt umber to the mixture and paint another swatch. Add more burnt umber and burnt sienna to the mixture and paint another swatch. Continue adding more burnt umber and paint another two swatches, getting progressively deeper in color.

 Using this method, you can make a skin tone darker by adding burnt umber, more golden by adding yellow ocher, more pink by adding burnt sienna, and paler by adding Chinese white.

PAINTING SIMPLE FACES

YOU WILL NEED Medium round brush · Small round brush · Watercolor paper, about 8 x 10 inches

COLORS Chinese white ◯ Burnt sienna ● Burnt umber ● Yellow ocher ●
Lamp black ● Venetian red ● Cadmium red pale ●

Using your medium brush, paint six simple oval-shaped faces, roughly an inch and a half tall, and add necks. Work from left to right, top to bottom. For the first head use a mixture of Chinese white and burnt sienna. For the second head use a mixture of Chinese white, burnt sienna, and burnt umber. For the third head use a very light mixture of Chinese white and burnt sienna. For the fourth head use a dark mixture of burnt umber and burnt sienna. For the fifth head use a mixture of burnt sienna, yellow ocher, and Chinese white. For the sixth head use a mixture of Chinese white and yellow ocher.

Add hair to the heads using your small brush. Add hair to the first head using burnt umber. Add hair in a bun to the second head using lamp black; make the black mixture as dry as possible to give it texture. Add long hair to the third head using burnt sienna. Add hair to the fourth head using lamp black and the dry-brush technique

to add texture. Paint short hair on the fifth head using a mixture of burnt umber and lamp black. Paint straight hair on the sixth head using lamp black and downward brushstrokes.

Using your small brush, add the following details to the faces. Use burnt umber to add noses to all the faces. Use Venetian red to add lips to the second face. Use cadmium red pale to add lips to the third face; use watered-down cadmium red pale to add cheek color to this face; and use burnt umber to paint freckles across the nose. Use cadmium red pale to paint lips on the sixth face. Use burnt umber to paint a simple line for the lips on the first, fourth, and fifth faces.

Using your small brush, add the following details to the faces. Use lamp black to paint eyes on all the faces, and add whites to the eyes using Chinese white. On the first face, use lamp black to paint glasses and burnt umber to paint eyebrows. On the second face, paint eyebrows using lamp black. On the third face, paint eyebrows using burnt sienna. On the fourth face, add eyebrows using lamp black. On the fifth face, add eyebrows and a beard using burnt umber. Add eyebrows to the sixth face using lamp black.

Using your small brush and a watery mixture of burnt umber, carefully outline the faces and necks. Where there is long hair (third and sixth faces), you just need to add shadows under the chin.

Using your small brush and a watery mixture of lamp black, paint a collared shirt on the first person. Using your medium brush and lamp black, paint a simple black T-shirt on the second person. Using your small brush and a watery mixture of lamp black, paint the outline of a blouse on the third person and add polka dots using a darker mixture of lamp black. Using your medium brush and lamp black, paint a simple black T-shirt on the fourth person. Using your small brush and a watery mixture of lamp black, paint a collared shirt on the fifth person. Using your small brush and a watery mixture of lamp black, paint the outline of a T-shirt on the sixth person and add horizontal stripes using a darker mixture of lamp black.

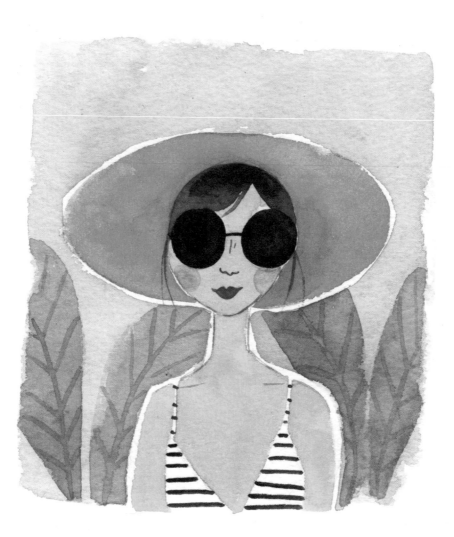

LADY IN A HAT

As I have said, human beings are a very complex subject to paint. This simple exercise allows you to practice painting skin tones and hair colors without having to worry too much about facial and body proportions, since the woman is wearing large sunglasses and is cropped a little below the shoulders. This painting will also help you develop your color-mixing skills.

YOU WILL NEED Large round brush · Medium round brush · Small round brush · Watercolor paper, about 8 x 10 inches · Pencil · Tissue

COLORS Burnt sienna ● Yellow ocher ● Chinese white ○ Lamp black ● Sepia brown ●
Venetian red ● Cadmium red pale ● Phthalo green ● Permanent carmine ●

Sketch out a woman wearing a large sun hat, bikini top, and large sunglasses with your pencil.

Paint her skin using a mixture of burnt sienna, yellow ocher, and a tiny bit of Chinese white and your medium brush.

Once the skin is dry, use a small brush and lamp black to paint the woman's sunglasses and stripes on her bikini top.

Once the sunglasses are dry, use a small brush and sepia brown to paint the woman's hair. Add more pigment toward the roots of her hair. Using your small brush and Venetian red, paint the woman's lips. Using your medium brush and cadmium red pale, paint the woman's sun hat. Add more pigment to the center of the hat. Using your small brush and a watery mixture of burnt sienna, paint the woman's cheeks. With your small brush and sepia brown, paint the woman's nose, add loose strands of hair, and outline her face and neck. It is important to do this as lightly and delicately as possible. Once you have picked up the sepia brown paint with your small brush and before you start adding the details, use a tissue to take off the excess paint so the lines are not too thick.

Using a mixture of phthalo green and permanent carmine and your large brush, paint the background. Leave a white outline around the woman.

Using a darker mixture of phthalo green and permanent carmine and your medium brush, paint large rounded leaves behind the woman. When these are dry, add more phthalo green and permanent carmine to the green mixture to make it darker and use your small brush to add veins to the leaves.

PICNIC IN THE PARK

A walk around your local park—surrounded by everyone from dog walkers to children riding bikes to ducks on the pond—is a great source of inspiration. In this painting, I have taken inspiration from two people having a picnic. We will be layering colors to create a pattern on the picnic blanket and the girl's shirt, as well as layering shadows over other parts of the painting.

YOU WILL NEED Medium round brush · Small round brush · Watercolor paper, about 8 x 10 inches
Scrap or printer paper for rough sketches · Tissue · Tracing paper · Pencil
COLORS Phthalo green ● Permanent carmine ● Cadmium red pale ● Lamp black ●
Ultramarine blue ● Burnt umber ● Burnt sienna ● Yellow ocher ● Sepia brown ●
Olive green ● Venetian red ●

Lightly sketch out the two people sitting on the picnic blanket, the glass bottles, the apple, and the cooler with your pencil. You might want to practice sketching this composition on scrap or printer paper first. Begin by building the sketch out of simple straight lines as much as you can. Pay attention to the posture of the two people sitting and where their weight is resting. The boy is leaning forward and the girl is leaning back. Take a step back when you've finished sketching to check that everything is in proportion and adjust the drawing if not. If you're really struggling, you could use tracing paper to copy the sketch out of this book onto your watercolor paper. Place the tracing paper over the sketch in

the book and draw over it. Flip the tracing paper over, place it on some scrap paper, and draw over the lines again (this step stops the image from being reversed). Flip it over again, place it on your watercolor paper, and draw over the lines once again. Once you have transferred the image to the watercolor paper, lightly draw over the lines with your pencil to define them and add detail; this will also help you understand how the lines fit together to create complex forms.

Using a watery mixture of phthalo green and a tiny bit of permanent carmine and your medium brush, paint the boy's shirt. Don't worry about leaving little white spaces around the collar and sleeves. Using a watery mixture of cadmium red pale and your medium brush, paint the girl's shirt. Whilst it is still wet, add more cadmium red pale to the right-hand side of her shirt to create more-concentrated color.

Using a mixture of permanent carmine and lamp black and a small brush, paint the boy's cap, adding more pigment to the inside of the bill. Using a mixture of permanent carmine and a small amount of phthalo green, paint the boy's shorts using a medium brush. Using a watery mixture of ultramarine blue and lamp black and a medium brush, paint the girl's jeans. Add more

pigment to the underside of her front leg, and to the leg tucked behind, to indicate shadows. Using a small brush and cadmium red pale, add flowers to the girl's shirt.

Using a watery mixture of burnt umber and burnt sienna and your medium brush, paint the girl's skin. Using a watery mixture of burnt sienna and yellow ocher and your medium brush, paint the boy's skin.

Using your small brush and yellow ocher, paint the handle and base of the cooler. Using lamp black and your small brush, paint the girl's sunglasses and hair. Take excess water off the brush with a tissue first before painting her hair to get a textured effect. Paint the boy's sunglasses using your small brush and lamp black. Using sepia brown and your small brush, paint his hair and the sole of his shoe. Using burnt umber and your small brush, paint liquid inside the glass bottles. Using cadmium red pale and your small brush, paint the apple. Add a touch of olive green whilst the apple is still wet.

Using sepia brown and your small brush, add shadow to the left-hand side of the glass bottle next to the girl and a straw, and outline the cooler lid. Using a watery mixture of burnt umber and your small brush, paint the girl's nose, add shadow under her chin, and add shadow on the left side of the boy's arm. Using a watery mixture of cadmium red pale, paint a wide stripe along the edge of the picnic blanket with your small brush. Using your small brush and a watery mixture of yellow ocher, paint a wide stripe of color next to the first. Keep alternating stripes of cadmium red pale and yellow ocher across the blanket, following the direction of its outer edge and getting thinner into the distance.

Mix a teal color using phthalo green with a tiny bit of permanent carmine, and mix a magenta color using permanent carmine and a touch of phthalo green. Once the stripes on the blanket are completely dry, paint alternating stripes of magenta and teal perpendicular to the original stripes. Follow the line of the edge of the picnic blanket and make them thinner as they get further back. Use Venetian red and your small brush to paint the girl's lips, then add more water to the red mixture and paint her cheeks. Using your small brush and sepia brown, add a stalk to the apple.

When that is completely dry, use your medium brush and a watery mixture of sepia brown to add shadows around the people and objects.

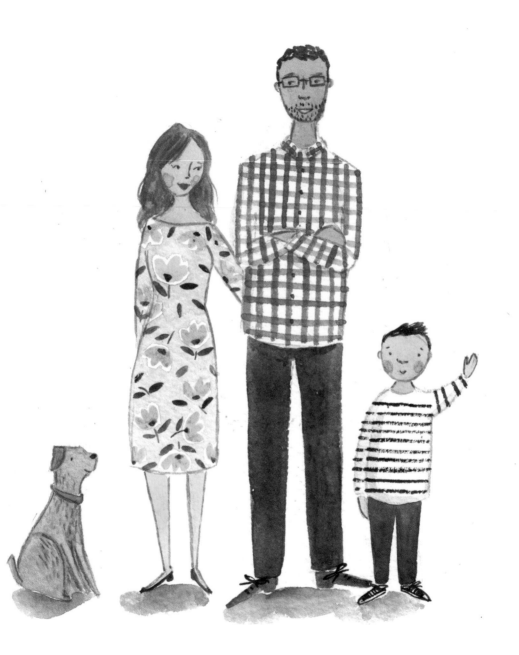

FAMILY PORTRAIT

Painting a group of people together is a huge challenge, even for an experienced artist, but when it comes to creating a portrait of the people you love, it's worth the effort. The key is to capture personality as well as likeness. In this project we will use a variety of techniques, including overlaying colors, dry brushing, and using colored pencil over watercolor to add texture and pattern to the clothes. However, the real focus is on drawing and painting the family group. When it comes to painting a portrait of your own family, use lots of photos as reference materials. Note the difference in height between different family members and consider how they might interact, or what their body language says about them. Think about what outfits you would like your family to wear. Colorful or boldly patterned clothes work well in paintings.

YOU WILL NEED Medium round brush · Small round brush · Watercolor paper, about 8 x 10 inches
Printer paper for rough sketches · Pencil · Brown pencil
COLORS Yellow ocher ● Burnt umber ● Burnt sienna ● Chinese white ○ Sepia brown ●
Ultramarine blue ● Permanent carmine ● Phthalo green ● Lamp black ● Venetian red ●

First sketch out the family members with your regular pencil, considering their relative height differences. It is a good idea to sketch them out on a sheet of printer paper first to get the composition and proportions right. Once you're happy with how the sketch looks, you can place your watercolor paper over the top of the printer paper and hold it against a window; the light should allow you to see the sketch underneath. Trace the sketch onto the watercolor paper

very lightly. By using this technique, you can practice sketching the family as many times as you need to to get it right without worrying about ruining sheets of watercolor paper.

Once you have a sketch of the family that you're happy with, paint the skin tones. Using your medium brush and a mixture of yellow ocher and burnt umber, paint the dog, leaving the collar white. Using a mixture of burnt sienna and Chinese white and your small brush, paint the woman's skin. Using a mixture of burnt sienna and yellow ocher, paint the man's skin. Using a mixture of burnt sienna and Chinese white, paint the little boy's skin.

Using a watery mixture of sepia brown and your small brush, add definition to the dog by painting areas of shadow around his legs and painting over his ear to make it darker. Using your small brush and a mixture of yellow ocher and Chinese white, paint simple flowers on the woman's dress. Using a watery mixture of sepia brown and your small brush, add shadows to the left-hand side of the man's and the boy's shirts.

Using a watery mixture of ultramarine blue and permanent carmine and your small brush, paint the woman's dress. Be careful not to paint over the yellow flowers; it's fine to leave white space around them. Using a mixture of permanent carmine with a tiny bit of phthalo green, paint vertical stripes on the man's shirt using your small brush. Using a mixture of lamp black and ultramarine blue, paint horizontal stripes on the little boy's shirt. Take some of the excess moisture off the brush first to give a textured, dry-brush effect to the stripes.

Once the woman's dress is completely dry, add leaves, stems, and centers to the flowers using sepia brown and your small brush. Using the mixture of permanent carmine and phthalo green and your small brush, paint horizontal stripes on the man's shirt. Where the two sets of stripes intersect there should be a darker section, giving the effect of gingham. Paint the boy's trousers and the dog's collar in the same mixture of permanent carmine and phthalo green using your small brush. Once that's dry, paint the man's trousers using a mixture of ultramarine blue and lamp black and your medium brush.

Using your small brush and burnt umber, outline the legs, hands, and faces of the family and add noses. Paint the woman's hair using burnt umber and your medium brush. Paint the man's hair, beard, and glasses using sepia brown and your small brush. Paint the boy's messy hair using sepia brown.

Using a sharp regular pencil, draw eyes on all members of the family and smiles on the man and boy. By using a sharp pencil, you have more control than with a brush and you have the option of rubbing out and adjusting the eyes if you make a mistake. Using Venetian red and your small brush, paint the woman's lips. Be careful not to have too much wet paint on your brush before you start, as this will require very delicate brushstrokes. Using a watery mixture of Venetian red and your small brush, paint the woman's and the boy's cheeks.

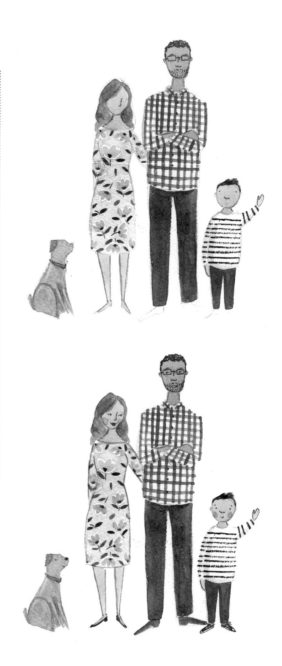

Add texture to the dog's fur by making numerous small dashes using a brown pencil. Add depth and texture to the woman's hair using the brown pencil, and use it to carefully draw her eyebrows as well. Paint the woman's and the boy's shoes using lamp black and your small brush. Paint the man's shoes using burnt umber and your small brush. When the man's shoes are completely dry, add shoelaces using your small brush and lamp black. Using your small brush, add Chinese white to the man's mouth. (Using white paint straight out of the tube will give the best opacity.) Roughly paint shadows under the feet of the family using a watery mix of sepia brown and your medium brush.

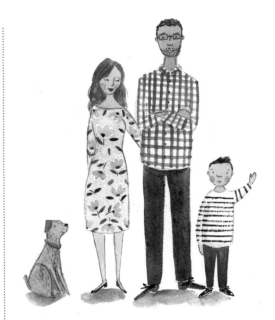

PAINTING
ANIMALS

Animals make fantastic subjects for a painting,
particularly our pets, or those familiar to us. Often they do not stay still for long
enough for us to sketch them from life, so I would recommend using a variety of
photos to help you choose your pose and build up a sketch. Start with simple poses—
for example, dogs standing in profile—or a cat sitting facing toward you, and focus
on capturing the personality of the breed rather than trying to achieve photo-realistic
detail. When it comes to sketching wildlife a trip to the zoo can be a great source of
inspiration, as can a trip to the local natural history museum.

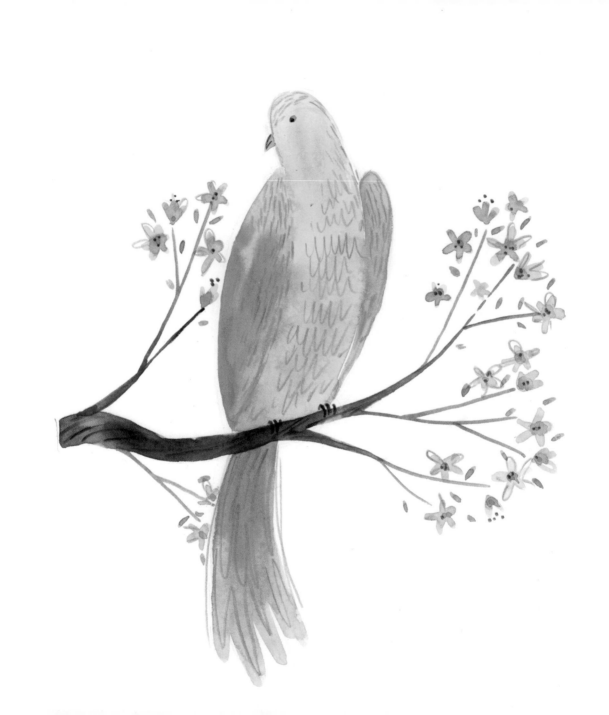

PINK BIRD

I often use water-soluble pencils, also called watercolor pencils, in my work. This piece uses water-soluble pencils for the initial sketch and to add detail to the finished painting. Colored pencils are perfect for adding interest and texture to this whimsical painting of a bird.

YOU WILL NEED Large round brush · Small round brush · Watercolor paper, about 8 x 10 inches Pink water-soluble pencil · Dark brown water-soluble pencil

COLORS Cadmium red pale ● Permanent carmine ● Sepia brown ● Phthalo green ●

Lightly sketch out a bird using your pink water-soluble pencil, and sketch the branch using your brown pencil. You can use a regular graphite pencil, but I like to use a water-soluble colored pencil. Because the pencil is water-soluble, the color dissolves when you paint over it, and when you finish the painting you can rub out any bits of pencil that haven't been covered with paint. This is my number-one tip for doing speedy paintings without having pencil marks in the final piece. Pick a colored pencil that is compatible with the final painting; I used pink and brown here. Paint the bird using your large brush and a watery mixture of cadmium red pale and permanent carmine. Whilst it's still wet, add more permanent carmine to the stomach and more cadmium red pale to the tail and wings.

Once it's completely dry, paint the branches using your small brush and sepia brown.

Once the branches are dry, add flowers using cadmium red pale and your small brush. Whilst the flowers are still wet, add more cadmium red pale to the center of each flower. Using a mixture of permanent carmine and phthalo green, add leaves with your small brush. Using sepia brown, paint the bird's beak and eye with your small brush.

Using your pink pencil, add feathers to the chest and wings of the bird. You can do this with wavy lines or repeating dashes. Add a loose outline to some of the flowers using your pink pencil. Add the bark texture to the main branch using your dark brown pencil. Using your small brush and sepia brown, add feet and detail to the bird's beak and eye. Paint tiny dots in the center of the flowers, again using your small brush and sepia brown.

CAT IN THE GARDEN

In this project, we use negative space by painting the area around the cat to help define it. We also use the wet-on-wet technique to create variation in tone, letting the two colors of the cat's fur blend naturally. We use masking fluid as well to give a smooth, even background and crisp white flowers.

YOU WILL NEED Medium round brush · Small round brush · Small old brush for applying masking fluid · Watercolor paper, about 8 x 10 inches · Masking fluid · Brown water-soluble pencil · Eraser

COLORS Sepia brown ● Lamp black ● Sap green ● Ultramarine blue ● Yellow ocher ●

Sketch the cat lightly using a brown water-soluble pencil. Paint simple daisies on either side of the cat using masking fluid and a small brush. Allow the masking fluid to dry completely.

Paint the cat using a watery mixture of sepia brown and your medium brush. Make a stronger mixture of sepia brown and paint the cat's tail, face, and front legs using your small brush. Work quickly to allow the colors to blend whilst they are still wet.

Once that is completely dry, use your small brush and a watery mixture of sepia brown to outline the cat and add fur. Using lamp black and your small brush, carefully add a nose, mouth, and eyes to the cat.

Paint the background using a watery mixture of sap green and your medium brush. Paint straight over the masking fluid and leave a thin white outline around the cat.

Once the background is completely dry, carefully remove the masking fluid using an eraser to reveal the crisp white paper underneath. Using your small brush and a mixture of sap green and ultramarine blue, paint stems and leaves behind the cat. Add more water to the sap green/ultramarine paint mix and add an additional layer of paint to the bottom of the background to make it darker. Using your small brush and yellow ocher, add centers to the daisies. Using sepia brown and your small brush, add whiskers to the cat.

DOGS

There is a huge variety within the world of dogs. This piece demonstrates the variation in scale and proportion among three different breeds: the Boston terrier (top), the fox terrier (middle), and the Afghan hound (bottom). In this piece we will use the wet-on-wet technique to create the subtle blending of colors within the fur and layering techniques to add depth and texture.

YOU WILL NEED Large round brush · Medium round brush · Small round brush · Watercolor paper, about 8 x 10 inches · Brown water-soluble pencil · Pencil

COLORS Sepia brown ● Yellow ocher ● Burnt umber ● Lamp black ●

First, lightly sketch out the three dogs using a regular pencil.

Using your medium brush and sepia brown, fill in the dark fur on the Boston terrier. Using your medium brush and a very watery mixture of sepia brown, roughly add shadow to the left-hand side of the fox terrier, focusing on its belly, chest, and legs. Using your small brush, carefully outline the fox terrier using sepia brown. Using a mixture of yellow ocher and burnt umber and your large brush, paint the Afghan hound, adding more water to the lower half of the dog to make the fur appear lighter in places. Allow the paint to extend past the pencil lines on the lower half of the dog to give the impression of long fur.

Once all the dogs are dry, use your small brush and lamp black to paint the Boston terrier's nose. Using a watery mixture of sepia brown and your small brush, outline the face, chest, and front legs of the Boston terrier. Using your medium brush and burnt umber, paint the fox terrier's ear and add brown spots to its fur.

Using a watery mixture of sepia brown and your small brush, make the Afghan hound's nose, back, and tail darker. Add more water to the sepia brown on the paper and blend it so there are no harsh lines. Use your small brush to paint the hound's ear using this more watery mixture of sepia brown.

Using a watery mixture of sepia brown and your small brush, add shadow to the chest and front legs of the Boston terrier. Using a stronger mixture of sepia brown and a small brush, add more patches to the fox terrier's fur. Using lamp black and your small brush, add an eye and a nose to the fox terrier. Using your small brush and a watery mixture of sepia brown, paint long strands of fur on the Afghan hound.

Using lamp black and your small brush, paint an eye, a nose, and a mouth on the Boston terrier. Using a watery mixture of sepia brown and your small brush, add fur to the Boston terrier's chest. Using the same mixture of sepia brown and your small brush, add fur to the fox terrier. Using your small brush and lamp black, add a nose and an eye to the Afghan hound.

Using your brown pencil, add small dashes to the Afghan hound's and fox terrier's fur to add even more texture.

GARDEN BIRDS

This piece is inspired by the wild birds you might see in your garden. This painting uses delicate color-blending techniques and layering of colors. Wildlife is a very traditional subject of the watercolor painting, but this painting takes the subject and gives it a slightly modern twist with its simplified shapes and use of texture and color.

YOU WILL NEED Medium round brush · Small round brush · Watercolor paper, about 8 x 10 inches
Brown water-soluble pencil

COLORS Burnt umber 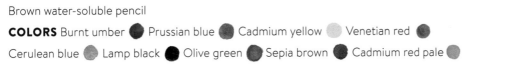 Prussian blue ● Cadmium yellow ○ Venetian red ●
Cerulean blue ● Lamp black ● Olive green ● Sepia brown ● Cadmium red pale ●

Very lightly sketch three birds sitting on a branch using a brown water-soluble pencil.

Using a watery mixture of burnt umber and your medium brush, paint the chest of the first bird, leaving its tail, wing, and head unpainted. Paint the second bird using the same watery mixture of burnt umber, leaving its tail, head, the bottom half of its wing, and the front of its chest unpainted. Add more brown pigment to the wing to make it darker. Using a watery mixture of Prussian blue and cadmium yellow, paint the third bird's chest. Add more water to the bottom of this chest to make it lighter.

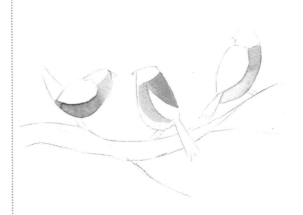

Paint the wing of the first bird using Venetian red and your medium brush, adding more pigment to one side to create a variation in tone. Paint the wing of the second bird using a mixture of cadmium yellow and burnt sienna and your small brush. Paint the tail and the right half of the wing of the third bird with cerulean blue and your small brush; add water to the painted half of the wing and blend it toward the middle of the wing, leaving a small strip of the wing unpainted. Whilst it is still wet, add Prussian blue to the tail.

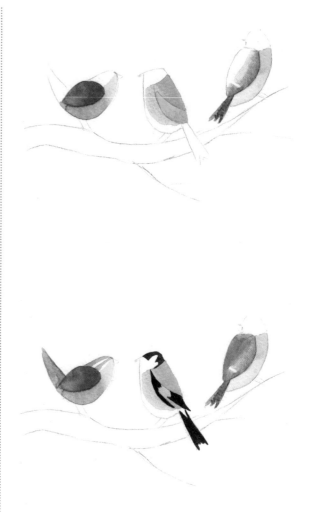

Paint the tail and two stripes on the head of the first bird with a watery mixture of Venetian red using your small brush. Using your small brush and lamp black, add details to the head, wing, and tail of the second bird. You will be painting over some of the yellow area of the second bird's wing, so make sure you are using a strong, opaque mixture of black. Using olive green and a medium brush, paint the left half of the wing of the third bird. Add more water to the edge of the green wash so that it appears to blend with the blue wash underneath.

Using your medium brush and a watery mixture of sepia brown, paint the branch. Using your small brush and the same color, add smaller branches coming off the main branch. Using a very watery mixture of sepia brown, paint the beak of the first bird with your small brush. Using a stronger mixture of sepia brown and your small brush, paint the legs of all three birds.. Using a watery mixture of sepia brown and your small brush, paint the beak and outline the chest of the second bird. Paint small dashes on the side of its head to indicate feathers. Using a stronger mixture of sepia brown and your small brush, paint the legs of all three birds. Once that is dry, paint the second bird's face using cadmium red pale and your small brush. Using Prussian blue and your small brush, add diagonal lines to indicate feathers on the wing and tail of the third bird. Paint the top of the third bird's head with a watery mixture of cerulean blue and your small brush. Whilst that is still wet, paint details on the lower half of its head using Prussian blue; the two colors should blend into each other slightly. Using your small brush and very watery sepia brown, paint the third bird's beak and outline its head.

Using a watery mixture of sepia brown and your small brush, add dashes and lines to indicate feathers on the first bird. Using your small brush and lamp black, paint an eye on the first bird. Again using a watery mixture of sepia brown and your small brush, paint dashes and lines to indicate feathers on the second bird. Using lamp black and your small brush, paint an eye on the second bird and add detailing to its beak. Using the same watery mixture of sepia brown and your small brush, add dashes and lines to the third bird to indicate feathers. Using a small brush and lamp black, paint an eye on the third bird. Using a small brush and sepia brown, add lines to indicate the texture of bark on the tree branch.

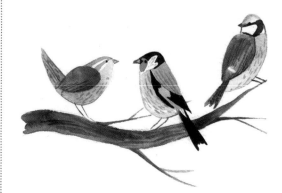

PAINTING ON LOCATION

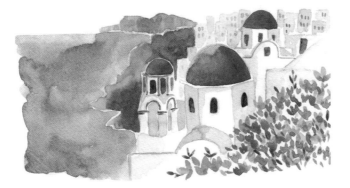

There is a long tradition of watercolor painting on location, or *en plein air*, which is the French term for painting outside. The compact, lightweight nature of watercolors makes them perfect for painting when you're out and about. I use a simplified watercolor kit when painting on location, which doesn't take up a lot of space in my bag or suitcase. I use a box of watercolors with lots of palette space for mixing. I wouldn't advise taking tubes of watercolors with you. Dry watercolors in a set are much better suited for painting on the go. I have a couple of waterbrushes, which are perfect for painting on location. The water is contained in the handle, so there's no need for pots of water. I use a pencil for sketching, with a good-quality rubber eraser on the end. I also use a mechanical pencil, which means I don't need to worry about it getting dull and thus don't need to carry a sharpener. I use a small, square hardback sketchbook with pages thick enough to take watercolors.

Travel provides huge inspiration for my work, and when I travel I deliberately pick places I know will be full of color and texture. I love going to vibrant cities like Seville or Marrakech, or to places with a strong history of folk art like Mexico or Peru. I always take a sketchbook and a set of watercolors with me, as well as my camera. There is something lovely about sitting on the beach or at a street-side café sketching away. When painting outdoors, efficiency is key: you don't want to spend all day in the same place, unprotected from sun or rain. It is necessary to work in a quicker, looser style than usual. It can also be a good idea to make sketches at the location and take some photos, so you can continue to work on the piece when you are at home.

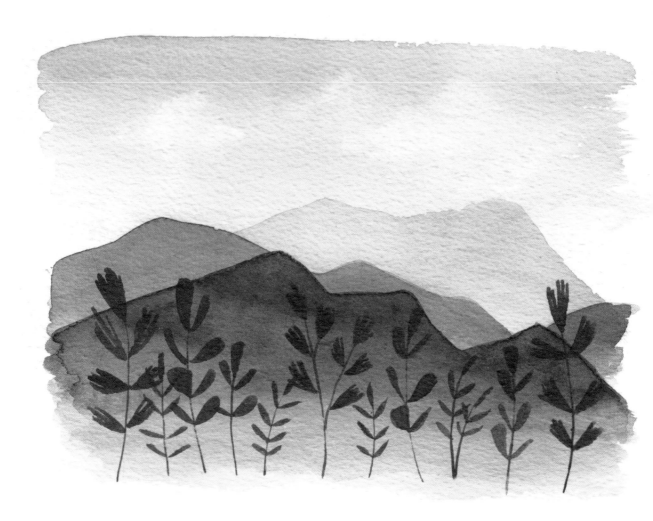

BLUE MOUNTAINS

In this exercise, you will practice creating a painting using only two colors. The key is to vary the intensity of the paint, giving different tones and a sense of depth and perspective.

YOU WILL NEED Large round brush · Small round brush · Watercolor paper, about 8 x 10 inches
Tissue

COLORS Prussian blue ● Yellow ocher ●

First, make a watery mix of Prussian blue and add a little bit of yellow ocher. The more yellow ocher you add, the more green it will become. Using your large brush, paint the sky with a pale blue wash. Move your brush backward and forward, horizontally moving down the page. Add more water as you go down the page so that the sky gets lighter and lighter. Whilst it's still wet, use a balled-up piece of tissue to lift some of the wet paint off the paper to create clouds.

Add more yellow ocher and Prussian blue
to the watered-down mixture. Using your large
brush, paint the first mountain, which should be a
slightly darker blue than the sky. Add more water
as you work down the page, so that the bottom of
the mountain fades out.

Add more Prussian blue and yellow ocher to
the mix to make it more intense. When the first
mountain is dry, paint the second mountain over-
lapping it. As before, fade the mountain out at the
bottom using extra water.

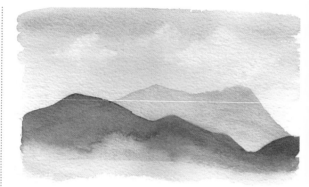

Once the second mountain is dry, paint the
third mountain overlapping it using a darker
tone of blue, in the same way as with the previous
mountains. You can keep going with more moun-
tains, but I've stopped at three.

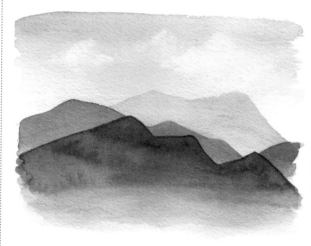

You can also add silhouetted details to the foreground using an even deeper shade of blue and a small brush.

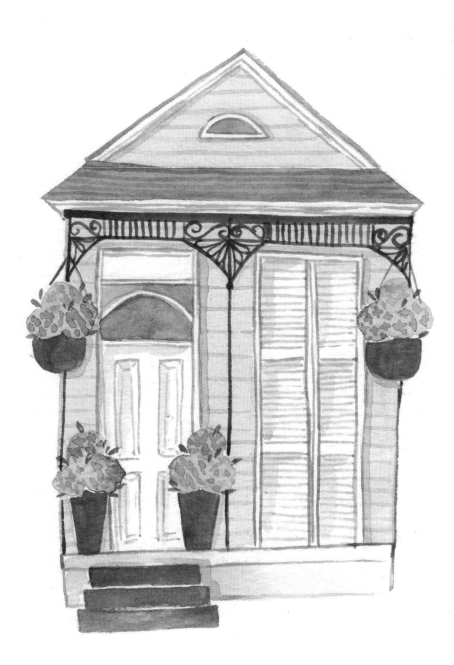

COLORFUL NEW ORLEANS HOUSE

BEGINNER

This painting is inspired by the traditional shotgun houses of New Orleans. This simple, colorful, one-story house is the perfect place to start developing your skills in painting houses. We will be layering colors to add texture and depth in this painting.

YOU WILL NEED Large round brush · Medium round brush · Small round brush · Watercolor paper, about 8 x 10 inches · Pencil

COLORS Permanent carmine ● Cadmium red pale ● Ultramarine blue ● Cadmium yellow ●
Sepia brown ● Venetian red ● Lamp black ● Olive green ●

Very lightly sketch out the house and the potted and hanging flowers with your pencil. Don't worry about filling in all the details; the sketch is just there to help you get the composition and proportions right. Start by lightly sketching a tall rectangle for the main house and add a triangle on top for the roof. Draw a center line down the middle of the main rectangle, then add two tall rectangles on either side for the door and window. Add a thin horizontal rectangle to the bottom of the main rectangle for the porch, then add small horizontal rectangles for the steps. Once you have these elements sketched in, you can add details like the hanging baskets, flower pots, and lines on the shutters and roof.

To paint the background of the flowers, create watery mixtures of permanent carmine, cadmium red pale, a purple mixture of permanent carmine and ultramarine blue, and an orange mixture of cadmium red pale and cadmium yellow. Apply these colors one after another with your medium brush to allow the colors to blend.

Once that's dry, paint the house itself using a watery mixture of permanent carmine and ultramarine blue and your large brush.

Once that's dry, use sepia brown and your medium brush to paint the roof of the house and the hanging baskets. Using the same sepia brown mixture and your small brush, add details to the front door, shutters, porch, and roof.

Once that's dry, using a watery mixture of permanent carmine and ultramarine blue and your small brush, paint horizontal lines on the house to give the effect of wood siding. Add a line of shadow to the right-hand side of the front door, shutters, and small window. Paint the flower pots and front steps using Venetian red and your medium brush. Using your small brush, add dabs of permanent carmine, cadmium red pale, and a mixture of permanent carmine and ultramarine blue to indicate flowers in the hanging baskets and flower pots.

Using your medium brush and a watery mixture of sepia brown, add shadows to the shutters, front door, and porch. Using a stronger mixture of sepia brown and your medium brush, fill in the windows. Using your small brush and the same mixture of sepia brown, add horizontal lines to the roof to indicate tiles. Once that's dry, use lamp black and your small brush to add the ironwork to the porch. Using your small brush and olive green, add leaves to the flower pots and hanging baskets. (See final painting on page 200.)

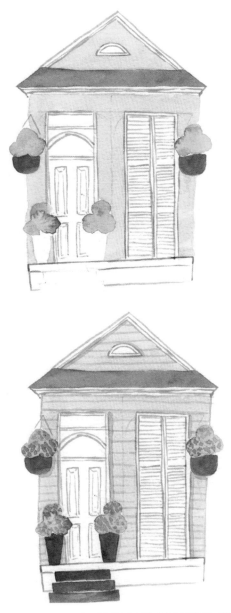

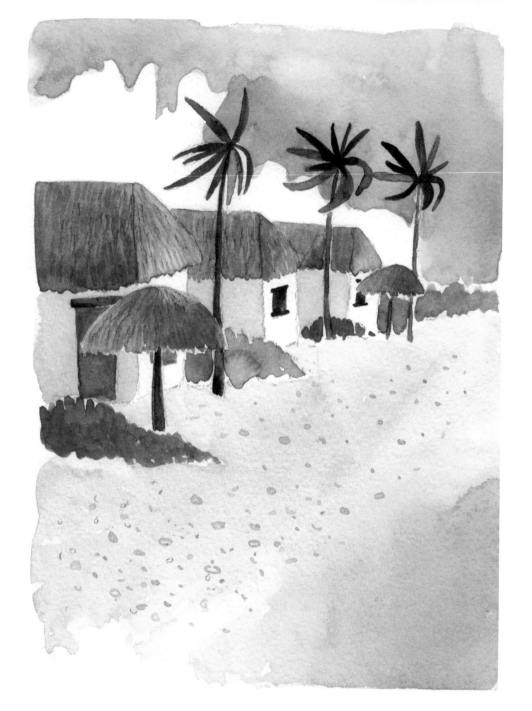

MEXICAN BEACH

This piece is inspired by the beach in Tulum, Mexico. We will be using the wet-on-wet technique to seamlessly blend the sand with the ocean. We will also be looking at perspective and using shadow to create depth and dimension.

YOU WILL NEED Large round brush · Medium round brush · Small round brush · Watercolor paper, about 8 x 10 inches · Brown water-soluble pencil

COLORS Yellow ocher ● Sepia brown ● Cerulean blue ● Lemon yellow ● Olive green ● Venetian red ●

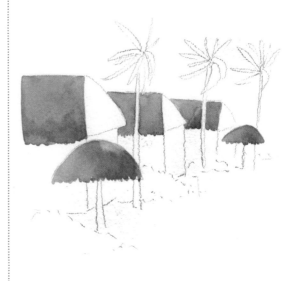

Using a brown water-soluble pencil, lightly sketch out three beach cabanas, palm trees, beach umbrellas, and greenery.

Using a mixture of yellow ocher and sepia brown and your medium brush, paint one side of the cabana roofs and the tops of the umbrellas. Add more sepia brown whilst the paint is still wet to add variety of tone.

Paint the front of the cabana roofs using your medium brush and a lighter mixture of yellow ocher and sepia brown. Using your medium brush and sepia brown, paint the trunks of the palm trees and the bases of the umbrellas.

Make up a large amount of watery yellow ocher with a tiny bit of sepia brown. Also make up a large amount of cerulean blue with a touch of lemon yellow. You will be using these colors to paint the sand and the sea. You will need to work quickly to fill in this large area evenly and to allow the colors to blend. Using your large brush and the yellow ocher mixture, paint the sand, adding more water as you move down the page. Whilst the paint is still wet, paint the sea using the cerulean blue mix and your large brush. Work upward from the bottom of the page, adding more water as you go until you meet the sand. Because both washes will be very watery, they will blend naturally where they meet. Be careful not to smudge this area whilst it's drying.

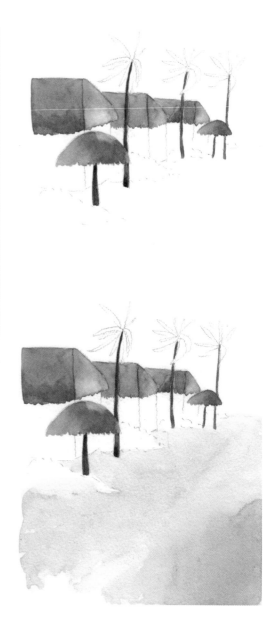

Once the sand and sea are dry, use your medium brush and a watery mixture of sepia brown to paint shadow on the left-hand side of the cabanas. Using your small brush and sepia brown, add vertical lines to the cabana roofs and the tops of the umbrellas. Using your small brush and a watery mixture of sepia brown, paint pebbles on the beach, getting smaller into the distance.

Using your large brush and a mixture of cerulean blue and lemon yellow, paint the sky, leaving a white space above the cabanas to indicate clouds.

Using a mixture of olive green and Venetian red and a small brush, paint the palm fronds. Vary the amount of water in the leaves to add variety of tone. Using your medium brush and a mixture of olive green and a tiny bit of yellow ocher, paint the greenery around the cabanas.

Using your medium brush and sepia brown, paint windows and doors on the cabanas. Using your brown water-soluble pencil, add vertical dashes to the cabana roofs and the tops of the umbrellas and draw additional pebbles in the foreground on the sand.

SEVILLE STREET

In this painting, I have attempted to capture the charm of a traditional residential street in Seville, Spain. The painting is deliberately loose and not too perfect. The colors and black line work bring it to life. This painting combines the skills of creating large washes, layering colors to create depth, and adding small details in black.

YOU WILL NEED Large round brush · Medium round brush · Small round brush · Watercolor paper, about 8 x 10 inches · Pencil

COLORS Cadmium red pale ● Alizarin crimson ● Yellow ocher ● Burnt sienna ● Lamp black ● Sepia brown ● Viridian green ●

Start by sketching two horizontal lines on the paper with your pencil to show where the tops of the houses are and where the houses meet the street. By drawing the lines at an angle, you can make the houses get smaller and recede into the distance. Draw vertical lines to divide the houses.

Using a large brush, paint the houses in pale, watery washes of cadmium red pale, alizarin crimson, yellow ocher, and burnt sienna. Leave unpainted space at the bottom of some of the houses for black detailing. Leave a tiny bit of white space in between each house so that the colors do not bleed into each other. Once the houses are dry, paint the unpainted bottom sections with a watery wash of lamp black using your large brush.

Once the houses are dry, paint the street with a watery mixture of sepia brown and your large brush. Paint the street in loose, broad brushstrokes, leaving a bit of white space between the houses and the street. Don't worry about making it look too perfect.

When your background washes are dry, add the architectural detail to the houses using a small brush. Make sure the horizontal lines you add follow the angled perspective of the house; use the top or bottom edge of the house as a guide. On the first house, use yellow ocher and your small brush to create detail around the windows and balconies. For the other houses, use a darker tone of the background color and your small brush to create similar details. (To make a darker tone, you can simply use more pigment and less water, or add a little bit of the opposite color on the color wheel. For example, you can add a little bit of viridian green to the alizarin crimson to make it deeper.)

When the details are dry, use a mixture of viridian green and a tiny bit of alizarin crimson and your medium brush to paint long rectangles for the doors and shutters. When the doors and shutters are dry, use a darker mix of the green and your small brush to add vertical and horizontal lines to show the details on the shutters.

The last step is perhaps the most rewarding, as the small details in black bring the whole painting to life. Using lamp black and a small brush, paint the balconies, bikes, and bollards. You may want to sketch out more-complicated details such as the bikes in pencil first. And make sure the mixture of lamp black on your brush isn't too watery, as you want precision lines and an intense black color. You can use a tissue to take off excess water to ensure a precise line.

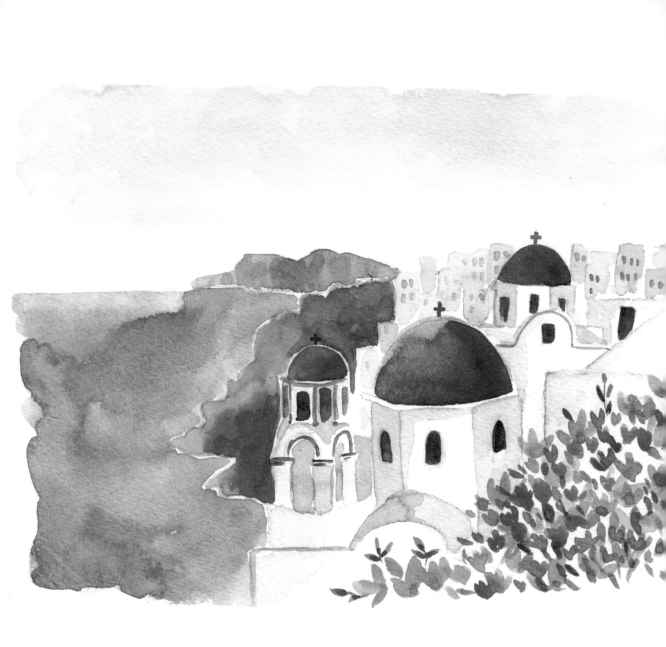

SANTORINI COAST

This classic view of Santorini allows you to practice painting shadows and perspective. We will be painting large, expressive watercolor washes, as well as small details to add a focal point to the foreground.

YOU WILL NEED Large round brush · Medium round brush · Small round brush · Watercolor paper, about 8 x 10 inches · Brown water-soluble pencil

COLORS Sepia brown Ultramarine blue ● Venetian red ● Yellow ochre ● Permanent rose ●
Olive green ● Prussian blue ● Lemon yellow ○

Sketch out the architecture, rocky shoreline, and horizon with a brown water-soluble pencil.

Using a watery mixture of sepia brown and your medium brush, add shadows to some of the planes of the church towers. Add more water to the mix and paint some of the other flat surfaces. Make sure some areas of the buildings remain unpainted where they are catching the light.

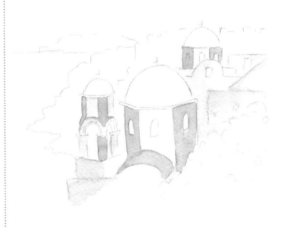

Using ultramarine blue and a large brush, paint the domes on the churches, adding more pigment to the right-hand side.

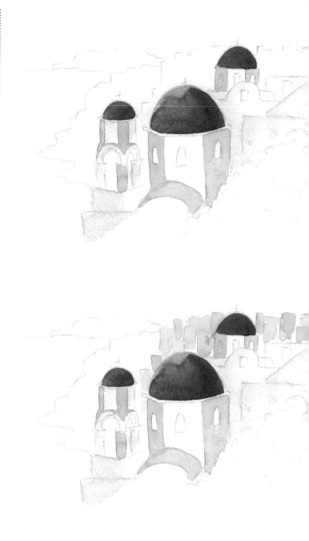

Once the domes are dry, paint the buildings in the background using your medium brush, watered-down Venetian red, and watered-down yellow ocher. Don't worry about painting these too precisely—just add rough blocks of color, allowing white spaces and overlapping colors.

Using a mixture of Venetian red, sepia brown, and a large brush, paint the rocks along the shoreline. Add more water to the color for the rocks in the background to make them appear farther away.

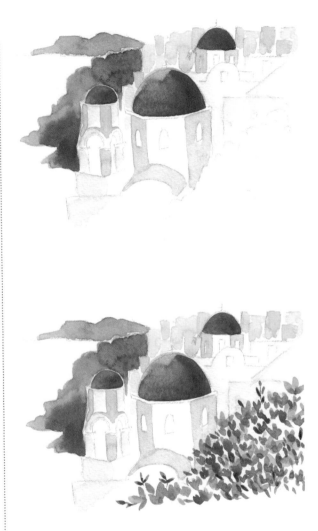

Using permanent rose and a tiny bit of ultramarine blue, paint bougainvillea in the foreground using your small brush. Paint smaller bougainvillea flowers first, and when they are dry add more water to the mixture and paint larger flowers over top, creating a layered effect. Whilst these larger flowers are still wet, add a dot of permanent rose to the centers. Once the flowers are dry, use your small brush and olive green to paint leaves around the flowers.

Using Prussian blue with a tiny bit of lemon yellow and your large brush, paint the sea. Add more water closer to the shoreline to make that area lighter. When that's dry, use your small brush and sepia brown to paint windows and detailing on the church towers in the foreground. Using a watery mixture of sepia brown and your medium brush, add more definition to the rocks on the shoreline and small windows to the buildings in the background.

When that is dry, paint the sky using a watery mixture of ultramarine blue and your large brush. Add more water as you work down the page so that the sky is lightest at the horizon. Using your small brush and sepia brown, add crosses to the domes of the churches.

BROOKLYN BROWNSTONE

ADVANCED

This painting is inspired by a classic Brooklyn brownstone. The hard architectural lines of the building are softened by the natural curves of the cherry blossom tree. To create this piece, we will be using masking fluid and layering colors to build up detail and depth.

YOU WILL NEED Large round brush · Medium round brush · Small round brush · Small old brush for applying masking fluid · Watercolor paper, about 8 x 10 inches · Masking fluid · Pencil · Eraser

COLORS Burnt umber ● Yellow ocher ● Sepia brown ● Venetian red ● Permanent carmine ●

Lightly sketch out the brownstone and the tree with your pencil. Pay attention to the size and proportions of the windows, making sure they are all in line and the same size. You can use a ruler to help you, but I prefer to sketch freehand. Use a small old brush to add dots of masking fluid at the end of the tree branches.

Once the masking fluid is completely dry, paint the background of the building using a mixture of burnt umber and yellow ocher and your large brush, painting over the masking fluid. Apply the paint in broad vertical and horizontal stripes, following the outline of the windows and doors to get even, neat coverage of the paper. If you are using this technique, it is important to work quickly to paint the whole building whilst the paint is still wet so you don't see the overlaps.

Once that is completely dry, use your small brush and burnt umber to outline the windows and doors and add decorative detailing.

Using your small brush and sepia brown, paint the flower boxes on the lower windows. Using Venetian red, paint the front door with your medium brush. Using a more watery mixture of Venetian red, paint the background for the front steps. Using your small brush and a mixture of burnt umber and yellow ocher, paint the banisters. Add more burnt umber to the top of the banisters.

Using sepia brown and your medium brush, paint the tree trunk and branches in front of the building. Using a watery mixture of sepia brown and a small brush, add shadows to the inside of the windows. Using your medium brush and Venetian red, paint the front of the steps. Using burnt umber and your small brush, add detailing to the front door and banisters. Let it dry completely.

Carefully remove the masking fluid using
an eraser. Also remove any excess pencil marks
outside of the painting using your eraser. Using
a small brush and a watery mixture of permanent
carmine, paint small dots to indicate blossoms on
the tree and in the flower boxes.

Using your small brush and sepia brown,
paint the railings in front of the lower floor. Add
small dashes with your small brush and sepia
brown to indicate bark on the tree.

Using your small brush and sepia brown, add shadows to the right-hand side of the windows and the underside of the window frames.

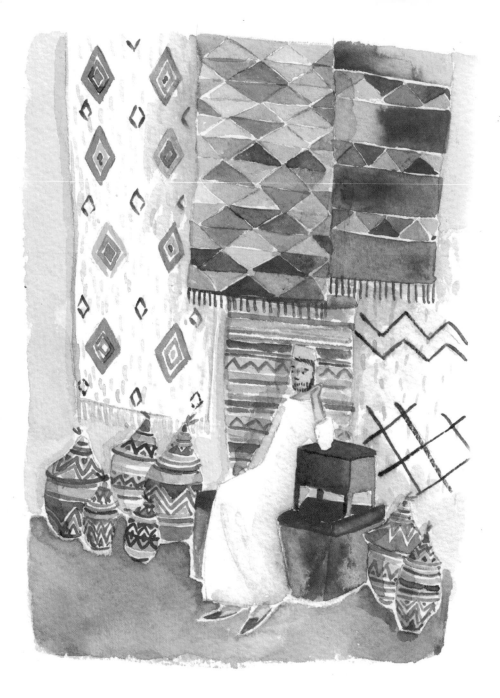

MARRAKECH MARKET

ADVANCED

This piece is inspired by the bustling, colorful markets of Marrakech. This complex composition, full of pattern and color, is a challenging but rewarding subject for a painting. This painting uses the skills you have been developing to paint small details and combine colors. The bright jewel tones are balanced out by rich earthy colors. The key with this painting is for it to be busy but not overwhelming. You need a light touch to stop the details from feeling overworked.

YOU WILL NEED Large round brush · Medium round brush · Small round brush · Watercolor paper, about 8 x 10 inches · Brown water-soluble pencil

COLORS Sepia brown ● Permanent carmine ● Cadmium red pale ● Cadmium yellow ● Prussian blue ● Lemon yellow ● Venetian red ● Burnt sienna ● Burnt umber ●

Sketch out the scene with a brown water-soluble pencil. Pay attention to the perspective and the angle of the rugs hanging on the wall. Using a watery mixture of sepia brown and your small brush, outline some of the rugs and add texture to them. Add shadows to the robes and hat of the man sitting on the chest.

Once that is completely dry, use your small brush to start to fill in some of the decorative details on the rugs and pots with permanent carmine. Randomly fill in sections of the pattern, varying the intensity of the permanent carmine so that some areas are lighter and some are darker.

Wait until the permanent carmine is dry, then, using your small brush, start to fill in sections with cadmium red pale, varying the intensity as before so that some sections are lighter and some are darker.

Once the cadmium red pale is dry, use your small brush to start to fill in some of the sections with cadmium yellow. Once that's dry, make a teal color from Prussian blue and a tiny bit of lemon yellow and again fill in details on the rugs and pots.

Once that's dry, use Venetian red and your medium brush to fill in the remaining details on the rugs and pots. Also paint the front of the chest and the man's slippers using Venetian red. When painting large areas with Venetian red, add more pigment to the wet paint to add variety in tone.

Wait for the Venetian red to dry, then, using a strong mixture of sepia brown and your small brush, add details to the rugs with a white background. Using sepia brown and your small brush, paint the box the man is leaning on, painting one side at a time so that each one is defined and has a slightly different tone. Paint the man's skin using your small brush and a watery mixture of burnt sienna. Using your small brush and Venetian red, add tassels to the bottom of the rugs. Paint the remaining sides of the chest in Venetian red using your medium brush.

Using your medium brush and a watery mixture of sepia brown, add shadows to the rugs. Using your small brush and sepia brown, paint the man's hair, beard, and facial features. Once that is dry, use burnt umber and your small brush to add definition to his neck and arm, and add shadow across his eyes and the side of his face.

Using a very watery mixture of Venetian red and a large brush, paint the wall behind the rugs. Once it is dry, add another layer with your small brush to create shadow behind the rugs and pots. Once that is dry, paint the floor with a watery mixture of sepia brown and your large brush. Once that is dry, add another layer of sepia brown with your small brush to create shadows under the pots and around the chest.

FINAL THOUGHTS

Finding Inspiration

Once you have exhausted the projects in this book, the natural question is, what do I paint next? Inspiration is all around: it's just a case of learning to look for it. I find the best source of inspiration is out and about in my everyday life, not on the internet. It is very easy to be overwhelmed by the huge wealth of beautiful watercolor paintings you will find on Instagram and Pinterest. The problem is that there is no context to these images: you have no sense of how long they took to create, or even when they were created, and how many first drafts had to go into creating the final piece. You might have scrolled through two years' worth of work in 30 seconds. What I generally find happens is that seeing so much beautiful work by other people in such a short space of time makes me doubt myself. It makes me feel that my work should simultaneously be more colorful yet more muted, more complex yet more simple—basically less like me and more like everybody else that I admire.

This usually has two results: either you feel overwhelmed, paralyzed, and unable to create your own work, or you are a little too inspired and create work that imitates whichever artist you were looking at. My work has been copied many times by students and amateur painters. I understand why it happens and how easy it is to do. If you are spending a lot of time looking at the same few artists' work, it's natural that your work will start to look like theirs. The best antidote to this is to seek inspiration from as many different sources as possible, preferably away from a computer screen.

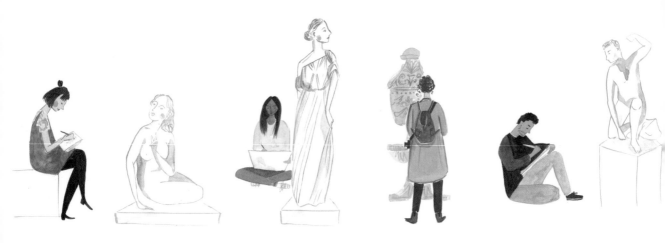

Where you find inspiration will be different for everyone. What inspires me may not inspire you, and that's a good thing. People's unique and diverse sources of inspiration are what makes their work personal.

I always take a sketchbook and a camera with me on trips to museums and galleries, and on trips abroad. People-watching is such a great free source of inspiration. If you like drawing people, it's great to spend time observing real people: their body language, what they wear, et cetera. My favorite people to draw are well-dressed older people and adorable children. I love

the costumes and sets in old films. If you like drawing objects, then vintage shops and antique shops are great places to find inspiration. I don't know why it is, but I find that old objects have so much more character and are just more inspiring than brand-new objects.

Copyright

As an image maker, it is important to have a basic grasp of copyright. Everybody learns by copying, and what you draw or paint in your sketchbook as practice is your own business. But once you post that work on the internet

or try to sell it, it is another matter. Copyright is a legal right created by law that grants the creator of an original work exclusive rights for its use. This means that if you do an original painting, you automatically own the copyright of that image. It is important as a painter not to encroach on the copyright of other artists or photographers. If you are using photographic reference material, be careful not to copy it too closely. Either work from your own photographs or photographs you have permission to use, or use a variety of different photographs to create one painting. I will often use one photograph to reference a person's pose, but the setting and the person's appearance will be completely from my imagination.

Again, it's natural to see another artist's work and feel inspired: there is nothing wrong with trying out a technique or material they've used, but it is wrong to copy an entire painting and pass it off as your own original idea. It is important to develop your own unique ideas, looking out for inspiration in your everyday life, and collecting photos and sketches.

Reproducing Your Work

Many of the people I teach want to turn their finished paintings into postcards and greetings cards, but they don't know how to digitize and reproduce their work. The simplest way to create a digital version of your painting is to use a scanner. Flatbed scanners are relatively cheap to buy, or you might already have one that's built into your printer. Scan your painting at a minimum of 300 DPI (Dots Per Inch). You can edit this in your scanner's advanced settings. The higher the resolution, the better quality the scan and the bigger you can print it. I edit my scanned images using Photoshop, but you can use any photo-editing software. Adjust the brightness and contrast so that the white background of the paper is completely white, without shadows, texture, or marks, and make sure the

colors are rich and bright. I always edit my scans subtly so they look as true to life as possible.

When it comes to getting your artwork printed, make sure the image file is cropped to the dimensions specified by the printer, that it is high resolution (at least 300 DPI), and that it is either a JPEG or PDF. Sending a low-resolution file will result in a grainy, pixelated print. Sending a file with the wrong dimensions could result in the final print being cropped or stretched. When I get postcards and greeting cards printed, I look for a textured paper similar to watercolor paper, though it is a personal preference whether you prefer a matte cardstock or a gloss finish. When looking for printers to reproduce your work, order a sample pack of paper from them if possible, to see the quality of both the paper and the printing before placing an order.

Finding Your Style

A lot of people worry about finding their style. I think your artistic style is a bit like your handwriting: it's intrinsic to you and you can't force it. If you ask ten people to all draw the same thing, each drawing will look different, despite all representing the same object. Each person's art will have a quality to their line work or brushstrokes that is unique to them. The best way to find your style is to just keep producing work. The more you paint and draw, the more your style will start to emerge. Don't worry if your style is taking a while to emerge; also, don't worry if you found your style but now it's starting to change. Your style will continually evolve as you are inspired by new things; try new materials and hopefully improve your drawing and painting skills. It's always interesting to go back to the first paintings you ever did, after practicing for several months or a year, and observe the progress you've made and the development of your work.

The very best advice I can give you is to just keep painting. Don't expect everything to be perfect straight away, but keep at it. Paint the things you love and enjoy the process.

ACKNOWLEDGMENTS

Thank you so much to my lovely agent Leslie, who believed in this project from the start. Without you I don't think this idea would have turned into a book. Thank you for being there every step of the way. Thank you to my amazing editor Kristen for doing such a fantastic job, and to Amanda the designer for making this book look so beautiful.

Thank you to my parents, for allowing me to pursue art from an early age and never telling me to get a real job. Thank you to my grandparents, for being my biggest fans. Thank you to my husband Alex and my best friend Katie for their endless support and belief in me.

INDEX